Athens Sketchbook

Foreword by Terry Kay • The Story of Athens by Loran Smith
Athens Contemporary Art Scene by Sandi Turner • Paintings by Local Artists

Indigo Custom Publishing

Publisher	Henry S. Beers
Associate Publisher	Richard J. Hutto
Executive Vice President	Robert G. Aldrich
Operations Manager	Gary G. Pulliam
Editor-in-Chief	Joni Woolf
Art Director/Designer	Julianne Gleaton
Designer	Daniel Emerson
Director of Marketing and Public Relations	Mary D. Robinson
Project Coordinator	Tom Carter

© 2005 by Indigo Custom Publishing

Loran Smith and the Publisher wish to acknowledge the following for their generous support and assistance in creating this book: Nash Boney, George Harwood, Bill Simpson, Liz Dalton, Ed Graham, and Jeff Wilson, Publisher, Athens Banner-Herald.

Cover art by: Lamar Wood

Printed in Peru.

Library of Congress Control Number: 2005936214

ISBN: (10 digit) 0-9770912-3-6
(13 digit) 978-0-9770912-3-2

Indigo
CUSTOM
PUBLISHING

Indigo custom books are available at quantity discounts with bulk purchase for educational, business, or sales promotional use. For information, please write to:
Indigo Custom Publishing, 3920 Ridge Avenue, Macon, GA 31210, or call 866-311-9578.

Athens Sketchbook

Foreword by Terry Kay • The Story of Athens by Loran Smith
Athens Contemporary Art Scene by Sandi Turner • Paintings by Local Artists

Foreword

There is a difference in distance as miles and distance as place. In the community of my childhood—Vanna by name—Athens was thirty-five miles (or thereabout) away, an easy enough ride along Highway 29, leaving out of Royston. Yet, as place, it was as remote as a foreign land, and to those of us who were seldom travelers, it was the City of Intimidation.

There was strut in the step of an Athenian, an expression of surety, of sophistication, on his/her face.

Country-come-to-town is what we were. Might as well have been in the middle of New York City, the way we gawked. And there was no doubt that we were being talked about, even if we never heard the words. It was in the quick look (and quicker look-away), in the flickering smile of amusement, in close-face whispers.

Or maybe it was only in our imagination.

I know this: as a young man, I took it upon myself to avoid Athens. No one was happier with the building of the Loop. It meant I could bypass the tangle of downtown on my trips to visit family in Vanna, and that was indeed pleasing.

Of course, it was absurd reasoning. I lived and worked in Atlanta. Atlanta. Only a man in serious need of counseling would live in Atlanta and be grateful for bypassing Athens.

I have had my counseling. Almost ten years of it. Making daily confessions to anyone who would listen: Athens is home.

It happened by accident. A friend, Grady Thrasher, invited me to use his house in Oconee County as a getaway for the writing of a book, and while there, I began to wander into Athens. It took less than a month to understand how misguided I had been. Within six months, my wife and I had found property having an Athens address. A year later, we were settled-in Athenians.

I think that is what this book is about—Athens as home, rather than place. It has its history, yes, and Loran Smith has chronicled that history in an engaging manner, skipping a polished word-stone across waters of time, yet it personally is individual to each citizen and visitor, much as the impressive and telling art of these pages reflects the interpretation, the seeing, and sensing of each artist.

Home, of course, means people, and that is what sold me on Athens. I came to understand that the strut in the step of the Athenians of my childhood was really a justified expression of pride. They lived and worked in a city unique among other cities in the state, having the University of Georgia as its principal occupant. Discerning, creative people teach at universities. Their influence ripples.

Yet, not everyone is a university person. Among my favorite people in Athens is a clerk in a grocery, proprietors of a fireplace shop, the manager of a bargain book store, owners of a sandwich shop, an accountant who once worked for the IRS, potters, painters, landscapers. I even have a cherished and comfortable friendship with a few lawyers.

I now know that one of the reasons I left Atlanta was the sorrowful fact that it was almost impossible to meet anyone. (There is a socio-cultural oddity about crowds: the more people you have, the more fragmented you become.)

In Athens, at home, I have found that people matter. My only regret is in realizing how many years I lost, getting here.

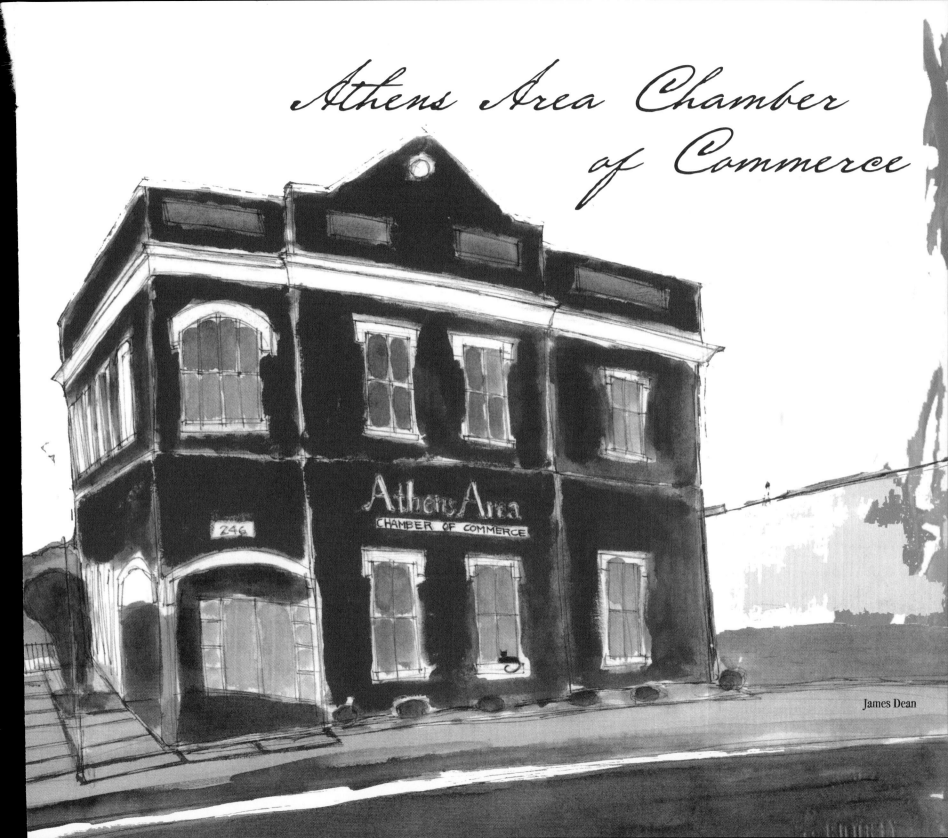

Athens Area Chamber of Commerce

246

Athens Area
CHAMBER OF COMMERCE

James Dean

The Athens Area Chamber of Commerce traces it roots to 1890 when Julius Cohen, clothing merchant, and William Russell, IV, the editor of the local paper, trudged the dirt streets of Athens garnering support from ninety-nine individuals and firms willing to contribute $5 towards its formation. Those were hard times for the national economy, however, and it would be a full decade later before the Chamber would realize its potential influence and authority. Moses G. Michaels, an influential 1907 entrepreneur, was credited at that time with leading the Board to raise funds to extend the University campus, promote a bond issue for road improvements, and procure the Athens and Jefferson railroads. It was the beginning of outstanding volunteer leadership that has become a foundation for the Chamber of Commerce, with 102 Chamber Chairmen and Chairwomen leading the way.

They've led efforts to grow the economy, expand Ben Epps airport, and build affordable housing. In more recent times, they've led efforts to build the Classic Center, establish a Convention and Visitors Bureau, initiate the Arts Council, and consolidate local government. Today, Chairwoman Annette Nelson continues that vision with a focus on local government services, small business growth, and continued University expansion. In a touch of irony, she and her husband now own the five-story Michael Bothers Building, built by 1907 Chairman Michaels, in the heart of the city, leasing space to several start-up businesses, as well as the University.

Along this storied path, nine professional presidents and many dedicated staff have provided expertise and guidance from a variety of locations. The first location was a wooden structure on Washington Street next to City Hall. In 1936, the Chamber moved to Civic Hall, which would later become the center of controversy between the local government and Chamber. The Mayor wanted the building for the city's sole use, but the Chamber was leasing some space to the Board of Education. When the Chamber and City couldn't reach agreement the Mayor padlocked the building and moved the Chamber furniture to the front lawn! The Chamber then took the matter to the Fifth Circuit Court of Appeals in New Orleans. When the City finally withdrew from the lawsuit, the Chamber once again gained control and continued to advocate for business.

In 1980, the Chamber moved to Firehall No.1, now the box office for the Classic Center, where they remained until 1991. At that time, they moved to make way for the Classic Center construction and took over the top floor of the Commerce Building. In 2003, during the Chamber's Centennial Celebration, they moved into their final and permanent home—246 West Hancock Avenue—only two blocks from the very first structure.

Current Chamber President Larry McKinney commissioned this watercolor by famed artist James Dean for the grand opening of the Chamber's newest headquarters on September 21, 2003.

Athens Area
CHAMBER OF COMMERCE

246 West Hancock Avenue • Athens, GA 30601
(706) 549-6800 • Fax: (706) 549-5636
Email: info@athenschamber.net

6

The Artists

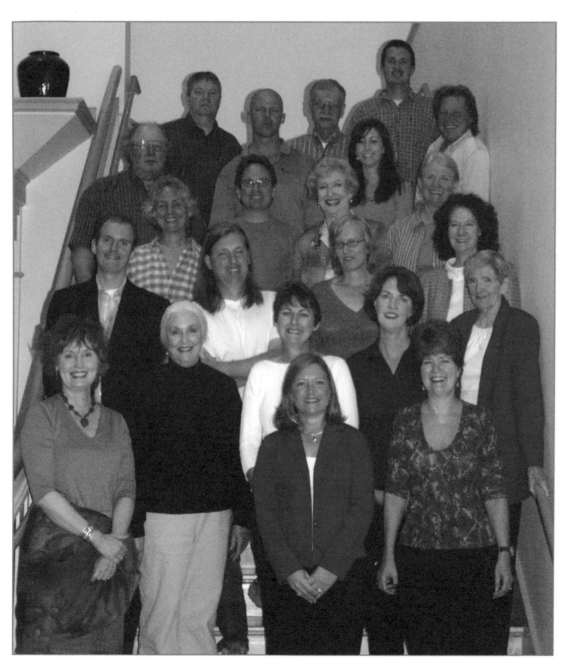

Left to right:

Row 6:
Paul Davidson
W. Joseph Stell
Jamie Calkin

Row 5:
Van Burns
Chris Wyrick
Angela Moore
Bryan Knudsen

Row 4:
Rene Shoemaker
Chris Cook
Nancy Roberson
Gwen Nagel

Row 3:
Mike Shetterley
Bruce Knfecht
Jo Adang
Celia Brooks

Row 2:
Autumn F. Strickland
Carol Downs
Chris Langone
Jill Lonte
Jean Gibson

Row 1:
Alice Pruitt
Mary Padgelek

Jamie Calkin

Athens Sketchbook

The Story of Athens

In the beginning, the University of Georgia and the town of Athens were nothing more than a forest glen near the banks of the Oconee River, whose significance and importance was not yet established.

The state was mostly a frontier. Historians say that the present location of the main campus was a hunting area for Cherokee Indians, who would later be forced from their lands for resettlement in Oklahoma—the humiliating Trail of Tears. If imagination is allowed to run rampant and ungoverned, you can see little Indian boys playing alongside a creek bed between what is today Lumpkin Street and East Campus Road.

Young men play there today, too, but we call them Bulldogs. They compete in the rugged Southeastern Conference, performing before an audience of over 93,000 each home game Saturday, aspiring to confirm that their football team can compete with the best in the nation.

In many ways the image of the town and the University is best known in the state and on a regional and national basis by the fortunes of the Georgia football team. This tends to overshadow the remarkable achievements and research accomplishments of some of the foremost artists, writers, scientists, and researchers in the country, past and present. The University is acclaimed for more than winning football championships.

From the beginning, when there was little else but the land, the founding fathers of the University set forth on a mission that underscored the importance of education, overcoming trial and tribulation. Many were the times when there were more struggles than laurels.

If you consider that it took a couple of days or more on horseback to reach Augusta – the most important city in the state north of Savannah – you realize

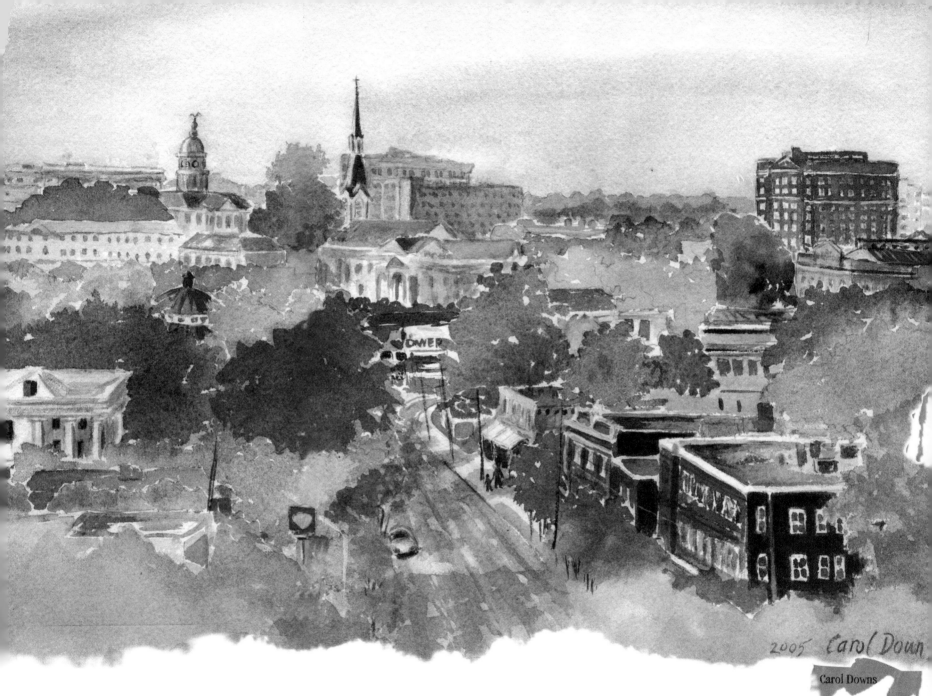

2005 Carol Down

Church and State, Art and Commerce, Home and School. Athens is known as the Classic City, and this downtown scenic view reflects its image.

11

that an inland community which was not blessed by any means of transportation, other than a small and inconsequential river, was likely to experience slow growth.

Yet, it was a seat of learning, and once development gained momentum and state support came about, the importance of the university would become firmly established. However, intermittent growth would rise and fall with the times.

Athens would become an important mill town and cotton center. Its citizens, including students and faculty, would give their lives in the Civil War. Times were challenging. Times were hard. Following the war and reconstruction, the University of Georgia would eventually grow and evolve into one of the nation's top universities, attracting students from all states and international addresses worldwide. The University now emphasizes minority enrollment, but it would be more than nine decades after the Civil War before the campus was integrated in 1961.

This is to say that while progress and innovation led to numerous distinctions over the years, it is fact that the town and campus were not without prejudices, blights, and shortcomings. Nonetheless, the history of the University and Athens reveals that there has always been a spirit and a sense of community that have enabled both to grow and prosper. Athens and the University, a land grant college, have always seemed to manage problems and move forward.

The University, chartered in 1785, came first, followed by the town. "In the very beginning it was called Cedar Creek," says retired University history professor, Nash Boney. "Because it was a university town, it naturally was associated with the Greek philosophers like Socrates and soon became known as Athens."

It would be sixteen years after its charter was official in 1801

before the University would hold classes. Because one man—Abraham Baldwin, a young Yale-educated minister—was imbued with far-sighted vision, the University of Georgia was chartered before the U. S. Constitution was signed and three years before it was ratified.

These developments allowed time for a community to spawn and attract a smattering of settlers, most of them enticed by the opportunity to make attractive land deals. The town of Athens was incorporated in 1806, five years after classes began, but from the outset, the town and the campus grew, expanded and developed together.

When the University prospered, the town benefited, and if the town made economic strides, the University became a grateful benefactor. The University eventually became the town's dominant employer, and what's good for the nation's oldest chartered state university is good for Athens.

The University's early development was shaped by two Yale men, which is why the football team's mascot became a Bulldog. The first mascot was a goat. Let's be grateful that the University went to the Dogs. Because of national television, many college football fans throughout the country are intrigued when they learn that Georgia's mascots are buried in Sanford Stadium. If there were a town crier sounding forth to the world today, he would shout out, "Come see us!" There's a great deal more to learn about our community than the reverence that we hold for our deceased and beloved mascots.

Because of cotton's importance and because of the railroad, Athens became a textile center with a number of mills located on the Oconee River. Cotton was king in the 1800s, which meant that slavery was prominent in the early growth of the area.

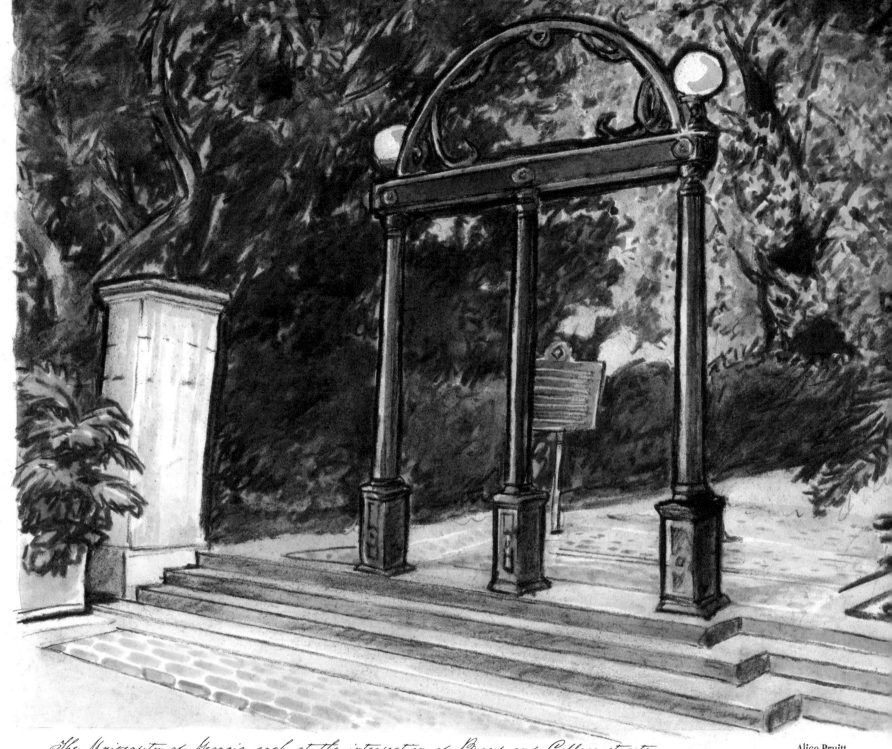

The University of Georgia arch at the intersection of Broad and College streets downtown is easily the most recognizable symbol of the University. The three columns represent wisdom, justice, and moderation.

Alice Pruitt

13

While the college was officially named the University of Georgia, in its formative years it was generally known as Franklin College, in honor of the early American patriot, Ben Franklin. According to University historian, E. Merton Coulter, Franklin "...personified learning and wisdom and who had at one time endeared himself to Georgians by acting as their agent in London." Clarke County was carved from huge Franklin County (also named for Ben Franklin) and included the communities of Athens and Watkinsville, both vying for importance. When the railroad linked Athens to Augusta in 1871, Athens achieved county seat status. Watkinsville became the seat of a new county, Oconee, which led to Clarke, named after Revolutionary War hero Elijah Clarke, becoming the smallest county in the state in terms of square miles.

The most significant growth for Athens, and the University to a lesser degree, took place in the three decades before the Civil War and after World War II (the population of Athens in 1860 was 4,000—slaves comprising at least half this number—and University enrollment was 100). Athens remained a sleepy little college town right on into the 1950s when a combination of circumstances caused a growth spurt that evolved into an upward spiral resulting in such a demand for admissions that there is a cap today on the number of freshmen who will be admitted. Total enrollment at the beginning of the twenty-first century had exceeded 30,000 and was growing.

In 1992, the state legislature approved a lottery which was to significantly benefit education in Georgia. Free tuition was made available to high school graduates with a B average or better, provided that they enrolled in a state college and maintained that average. The University of Georgia especially benefited with the top graduates from high schools choosing the state university to further their education. This has made it much more difficult to enroll at the University of Georgia.

Athens has become an ever expanding and lively town with diversified business interests from real estate to professional services to manufacturing. Poultry processing plants and makers of auto parts and other products have flourished, quietly contributing to the economy, but under the newsmakers' radar, influenced by the University.

After the University, the biggest employer in Athens is Athens Regional Medical Center, where open heart surgery is performed on a regular basis. Athens Regional and St. Mary's Health Care System continue to expand and offer employment opportunity. Doctors have flocked to Athens in recent years, finding attractive medical options but also attracted to the quality of life offered in the community.

In addition to the cultural opportunities, it is not lost on potential residents that the greater Athens area has five golf courses, including the Athens Country Club, designed by the preeminent and prolific Scottish-born designer, Donald Ross. In addition, the University has an eighteen-hole championship layout designed by Robert Trent Jones. An hour south of Athens on Lake Oconee you can find courses designed by Jack Nicklaus and Ben Crenshaw, both winners of the famed Masters tournament at the Augusta National Golf Club, which is less than two hours away.

A little known fact from the past is that the wealthy, elite planters from Augusta and Savannah chose Athens and nearby plantations for a summer retreat. Those from Savannah, in particular, sought to escape the searing heat and tropical miasma which engulfed the seaport town, to say nothing of the gnats and bugs that nauseated the coastal gentry. It was considerably cooler

in upland Athens, and for sure, you weren't required to fan yourself furiously to shoo the gnats away.

Some well-to-do planters moved in permanently, attracted to the cultural life of the college town. They built magnificent antebellum homes on Milledge and Prince Avenues, many of which still stand today, mostly occupied by fraternities and sororities. Unfortunately, many have been razed and destroyed.

Lately, a restoration of the Thomas Reade Rootes (T. R. R.) Cobb house on Prince Avenue has stimulated interest and appreciation for saving historical homes. This house was a gift from the father of his wife, Marion. Cobb was the founder of the University's Lumpkin School of Law and lost his life at Fredericksburg during the Civil War. The Cobb house, falling in disrepair, was dismantled years ago and shipped to Stone Mountain where it sat for years, unrestored, before being returned to Athens in 2004.

Demolishing an old home is like cutting down a tree. Once that is done, it can never be brought back. Two antebellum homes, built by the Michael brothers, were razed in the 1970s, a fact that is lamented to this day by historians and preservationists.

In 1860 the *Gazetteer of Georgia* had this assessment of the University: "No place surpasses it in refinement, morals, splendid residence, good society, and learned men. As Greece was enlightened by a city after which this town was named, so Georgia for years regarded this place. She gave laws to fashion and literature; and frequently from her college chapel politics sent forth its decrees—who should be Governor, Members of Congress, and sustain the highest offices...Other colleges have been established, yet she is still attractive, is thronged with the elite of the State and 'sits a queen.'"

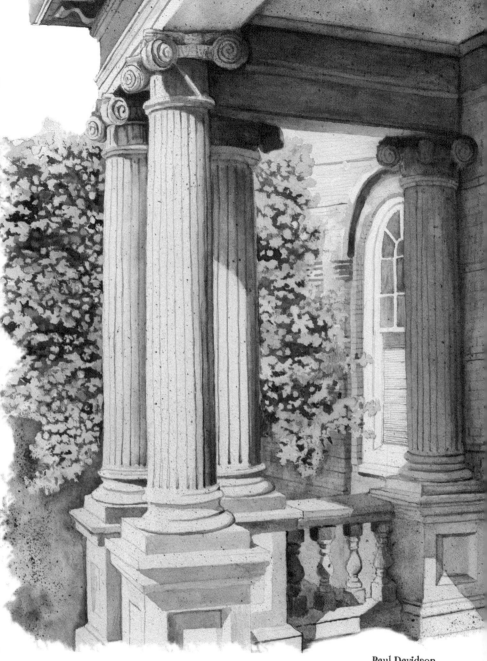

Paul Davidson

Athens City Hall was constructed in 1903. The architect was Lewis F. Goodrich from Augusta, Ga. City Hall housed offices, the Chamber of Commerce, and an armory for the local militia.

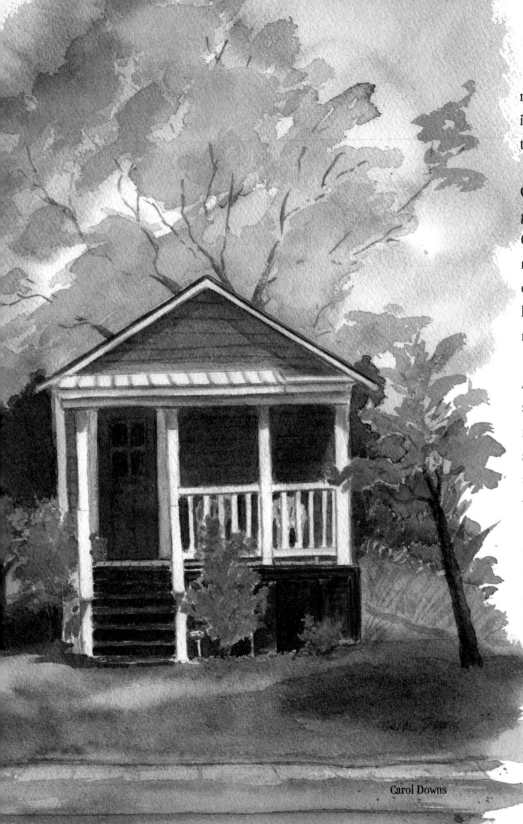

Carol Downs

When William Bartram, America's first native born naturalist/artist, traveled the Oconee River in 1773, he was inspired by what he saw and offered this description of what was to become present day Clarke County:

"At one particular place, where we encamped, on the Great Ridge, during our repose there part of a day, our hunters going out, understanding that their route to the low land on the Oconee, I accompanied them: We had not rode above three miles before we came to the banks of that beautiful river. The cane swamps, of immense extent, and the oak forests, on the level lands, are incredibly fertile; which appears from the tall reeds of the one, and the heavy timber of the other."

In the fall of 1867 – two years following the Civil War when Athens and the University reached a consequential nadir, barely surviving – John Muir, the legendary botanist, took a "Thousand-mile Walk" from Kentucky to Florida. He made a stop in Athens and wrote in his journal: "This is the most beautiful town I have seen on the journey, so far, and the only one in the South that I would like to revisit."

With natural beauty and a creative thrust from many learned and accomplished individuals, Athens has always possessed a charm and an attraction that leaves visitors smitten after visiting its environs. All too many matriculates are envious of their classmates who have been able to locate in the Classic City following graduation.

That, in part, is why the demand for Georgia football tickets in recent years has gone through the roof. The game brings

One of five shotgun houses on Rock Springs. The shot-gun house was one room wide, two-to-three rooms deep, a traditional worker's house.

alumni back to campus, and while there is limitless partying, socializing and flaunting of a deep and abiding passion for the Dawgs, many are drawn back for a retracing of steps of their days on campus. They might not actually revisit classrooms, but they stroll the campus for "feel" and for emotional fulfillment.

Most traditionalists have never met a campus they didn't like, taking delight in casually ambling through a campus. Where is the popular hangout? The quad! The Drag! What is that fountain over there? Look at the architecture and the landscaping. That bench under those trees. Is that where we would have sat and contemplated life? A campus is so alluring. It is a place of beauty, energy and inspiration.

Let's make a stop at the stadium. You can hear the band playing, the crowd cheering and see the autumn leaves falling. Anybody who has not experienced a fall Saturday on campus has missed something in life. Those who have, never want it to end, which is why they come back again and again.

When we return to the campus, we seek out our old haunts, take a meal at a favorite restaurant, even if it is a short-order hang-out that has more lore and calories than reputable cuisine.

As a place of learning, Athens has always offered cultural opportunities and, in recent years, economic development and business opportunity. It has been a quasi "boom town" of late.

The only time the University was ever closed was during the Civil War. It came agonizingly close to shutting down in 1961 when black students were enrolled. Gov. S. Ernest Vandiver, who had campaigned on a platform of segregation, agreed with several close associates to keep the doors open. His landmark decision became a progressive watershed for the institution.

Integration brought about tenuous times, nonetheless. There were aftershocks emotionally, and while tensions eased, it was a transition period which required restraint and bold leadership to avoid the confrontation and violence that befell several universities in the South.

From that point, minority enrollment increased gradually. Many black university graduates, including the first two admitted – the late Hamilton Holmes, who became a distinguished physician and Charlayne Hunter who rose to broadcast acclaim with CNN and National Public Radio – have become accomplished in a variety of fields.

Georgia integrated its football team in the early seventies, and the Bulldogs have never had a more beloved and popular player than Herschel Walker, who won the coveted Heisman trophy and led the Dawgs to the national championship in 1980.

In 2004, Damon Evans became the first black athletic director in the Southeastern Conference, another example of progressive leadership taking place in the state of Georgia.

Women, early in the 20th century, were slow to gain admission to the University. It was not until 1918 that pressure from the Colonial Dames and the Daughters of the American Revolution helped to bring about the admission of women as regular students.

As late as 1950, most of the women were housed and schooled at what was known as the Coordinate Campus in Normaltown, on the far reaches of Prince Avenue. In 1954, the U. S. Navy took over the property and installed its Supply Corps School. Women by this time were fully integrated at Georgia and had begun to occupy dormitories on main campus. Right on into the 1960s, women were required to live in dorms or sororities, and their dress had to conform to certain University rules.

The contributions of women in Athens and at the University

have been notable through the years. However, when the subject of women's suffrage came up, it was none other than Miss Mildred Lewis Rutherford of Athens, affectionately known as "Miss Millie," who was an outspoken opponent of women gaining the right to vote. It was a curious stance for a woman who had done so much to create educational opportunities for women. The Lucy Cobb Institute, under her leadership, grew in stature and became one of the leading schools for young women in the country.

Jeannette Rankin, who was to make Watkinsville her home, led a successful drive for women's voting rights in her native Montana and was twice elected to the U. S. House of Representatives. While her influence was noteworthy on a national basis, she was an inspiration to women in both Clarke and Oconee counties and the state of Georgia as well.

Moina Belle Michael, a teacher by profession, created a memorable symbol of World War I when she advanced the sale of poppies not only to memorialize those who lost their lives in the Great War, but to raise millions of dollars on behalf of disabled American veterans of all wars.

Mary Wright (1881-1946) was a diligent teacher and community leader for thirty-eight years as the African American principal of East Athens School. In recent years other women achieved a number of firsts: Jewel John, first female elected to the Clarke County Commission; Nancy Denson, first female on the Athens City Council and subsequently elected Tax Commissioner; Miriam Moore, first black female elected to the Athens-Clarke County Commission; Gwen O'Looney, first CEO of Athens-Clarke County Commission; and Louise McBee, former dean at the University of Georgia and the first female from Clarke County to be elected to the Georgia House of Representatives.

* * * * *

An interesting development in 1892 caused excitement that was to bring a stimulating influence to the University. A seed was planted that would sprout and grow to enlarged proportions. Chemistry professor Dr. Charles Herty introduced football to the University on January 30 when Georgia defeated Mercer 50-0 in Athens.

It was Herty's research, however, that set him apart. He developed the process by which paper was made from pine pulp. One of the state's great resources has always been pine trees, and Dr. Herty's breakthrough in his lab was to bring about a great and far-reaching economic impact for the state. Pine forests replaced boll weevil-infested cotton fields. Georgians, who spot pulpwood trucks on the back roads of the state, should offer a prayer of thanks to Dr. Herty. His research affects our daily lives in a big way. Feel the pages of this book and toast Dr. Herty.

Has anyone had a greater influence on the University than this man? The making of paper from pine pulp and initiating the game of football! What's more dominant in the state than pine trees and Bulldog football?

The life and work of Dr. Herty reflect the fact that academics and athletics should be compatible. Of course, he did not experience the pressure to win that was to become an all encompassing trend for colleges throughout the country.

Dr. Herty was not the only scientist to distinguish himself in Athens. Crawford Long, a University graduate, discovered ether anesthesia while a practicing physician and pharmacist in nearby Jefferson. Dr. Alfred Blalock perfected a procedure for "blue baby" treatment, one of the first of modern heart surgeries. Francis Slack was a member of the first team to split the uranium atom.

There have been many luminaries of note, from Eugene Black,

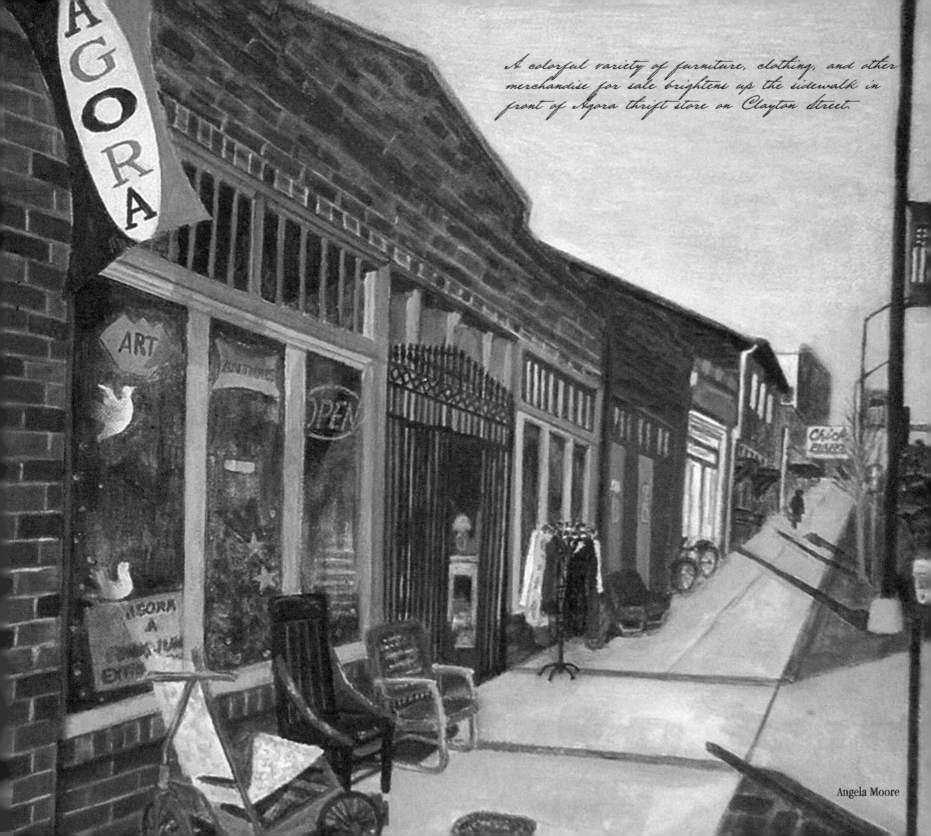

A colorful variety of furniture, clothing, and other merchandise for sale brightens up the sidewalk in front of Agora thrift store on Clayton street.

Angela Moore

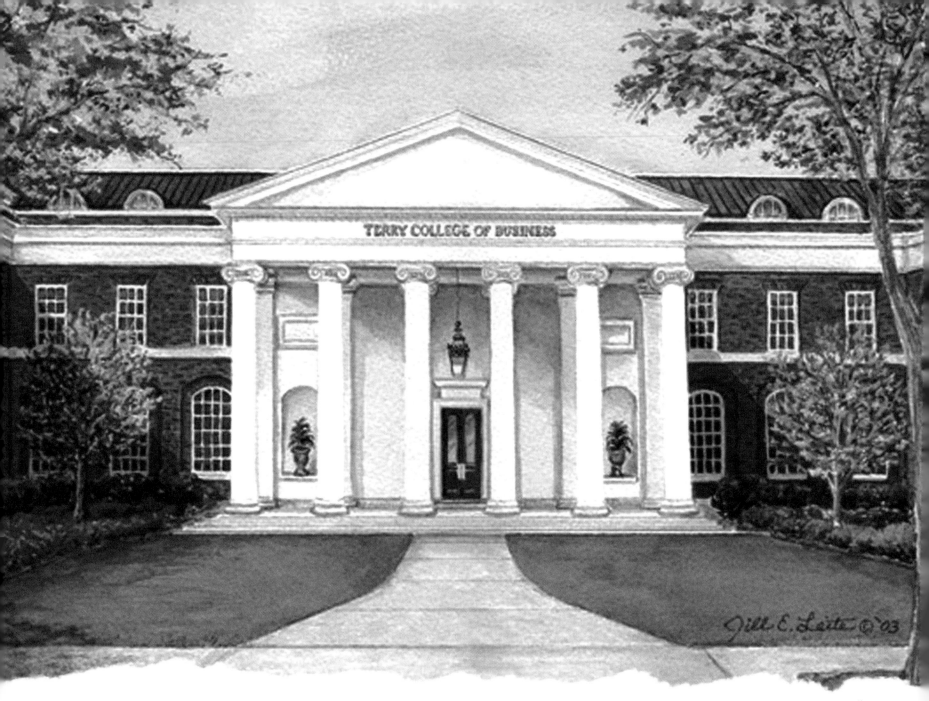

Jill Leite

Brooks Hall, home to the Terry College of Business, founded in 1912. Today, the Terry College of Business is consistently ranked among the top public business schools in the nation.

the first president of the World Bank, to former Secretary of State, Dean Rusk (not a graduate but attracted to the Georgia campus as a law professor for his post-government years), to the work currently being done in cloning by scientist Steve Stice. Chemist Henry Schaefer was elected recently to the American Academy of Arts and Sciences. Schaefer is internationally acclaimed for his research.

Peter Albersheim and Alan Darvill were among the wave of new professors brought to campus in the 1970s, and not only is their research in complex carbohydrates internationally noteworthy, they helped influence a trend that has brought millions of dollars to the campus for research. Ed Larson, former head of the history department, won a Pulitzer prize in 1997 for his book, *Summer for the Gods: The Scopes Trial and America's Continuing Debate Over Science and Religion.*

There were academically esteemed personalities like Lamar Dodd, renowned artist, and Eugene Odum, considered the Father of Modern Ecology, who were so prominent and celebrated in their respective fields that they pulled the University up to their exalted level.

It wasn't earthshaking when Dean of Journalism, John E. Drewry, originated the Peabody Awards in honor of philanthropist and financier George Peabody, a University benefactor from Columbus. (Peabody also was instrumental in establishing the University's School of Forestry). Today, however, the annual Peabody Awards, administered by the Grady College of Journalism and Mass Communications, are looked upon and coveted by the radio/television industry with the same affection that those in Hollywood reserve for the Oscars.

Of course, the university has had its colorful characters. Math professor Pope Hill often threw a piece of chalk out of the window, noting that the law of gravity would someday bring the chalk back through the window. A mischievous football player is said to have waited outside the window one day for the chalk to come flying out. He picked it up and tossed it back into the classroom to the delight of his unsuspecting classmates.

Dean of Men, William Tate, was colorful and unforgettable, whether he was breaking up a panty raid, keeping order at registration or speaking throughout the state. He was given to poking fun at himself and always referred to his age by integrating into his speeches the line, "When I walked back from Appomattox..." A man who truly cared about the University, he often said, "There's nothing finer than a Georgia boy with a Georgia education."

Traditionally, when the Bulldogs win a game, the freshmen students ring the chapel bell on North Campus until midnight. In 1965, when Vince Dooley, who had revitalized the football program, turned down an attractive offer from Oklahoma to stay at Georgia, the students considered it a Bulldog victory. They rang the chapel bell and Dean Tate joined them, happily taking a turn at ringing the famous bell.

Dan Magill, the University's most indefatigable promoter as Sports Information Director, tennis coach, and Secretary of the Georgia Bulldog Clubs, would open his welcoming remarks to gatherings across the state by saying, "Good evening fellow Georgia Bulldogs, chosen people of the Western World." Magill coached the Georgia tennis team to its first national championship in 1985.

Steadman V. Sanford, University President from 1932-1935 and later Chancellor of the University System, often sipped moonshine in the thirties with the famous waterboy, Clegg Stark, who stowed

away with the football team on road trips. "Clegg," said John Stegeman, a physician and historian, "integrated the railroads long before the Supreme Court."

In 1957, the Georgia Center for Continuing Education opened its doors. It also opened the eyes of many in Georgia, to say nothing for the countless visitors who came to campus. The late President O. C. Aderhold hired a visionary director, Hugh B. Masters, who initially irritated many entrenched on campus by advocating that the highest paid University staff members should be the chef and the landscaper.

Masters' logic was that if visitors, here for temporary short courses, felt good about the food they ate and the environment in which they lived, it would enhance their learning experience and leave a lasting and favorable impression of the University of Georgia.

"The Georgia Center was a catalyst for explosion and growth of the University in the last half century," says Bill Simpson, former director of public relations. "It opened the eyes of thousands of citizens in the state to what the University and the state could do and become. It made Georgians realize what Georgians could do. It was the first building on campus with air conditioning and carpet."

The Center was built in a pecan grove on South Campus. Masters had it written into the construction contract that the contractor would be heavily fined for every pecan tree that was destroyed. Happily, there were no fines.

If you visit the Georgia Center today, you will note that the rectangular construction of the building frames a courtyard in which a giant pecan tree stands sentry to countless visitors who pass through the building each year.

This story, though lesser celebrated, is one of at least four famous tree stories in Athens. At the corner of Dearing and Finley Streets, there is an aging oak whose legend is best known. "The Tree That Owns Itself" is a large white oak grown from an acorn of the original tree deeded many years ago by Colonel W. H. Jackson, who stipulated: "For and in consideration of the great love I bear this tree and the great desire I have for its protection for all time, I convey entire possession of itself and the land within eight feet of it on all sides."

In 1942 high winds toppled the original tree, but a seedling, carefully grown from one of its acorns, was planted by the Junior Ladies Garden Club in 1946. The club membership has tended the tree ever since. Some residents, including Dan Magill, have planted acorns from the tree, growing in their yards grandsons of "The Tree That Owns Itself."

Then there is the oak from Germany's Black Forest, brought home from the 1936 Olympics by Athletic Director, Herman Stegeman. Each gold medal winner was presented a seedling by Chancellor Adolph Hitler. Forrest "Spec" Towns, who won the Olympic high hurdles, gave the tiny tree to Coach and Mrs. Stegeman who watered, nurtured, and cared for it on the trans-Atlantic journey home. Stegeman had it planted behind the North Stands of Sanford Stadium.

Expansion of the stadium in 1967 brought about a transplant to the Coliseum. The original tree died, but Dean Tate procured a replacement seedling which stands over a bench at the northwest corner of the Coliseum, commemorating Towns' record setting victory in the Olympics at Berlin.

Finally, it is said that Robert Toombs, U.S. Senator and Secretary of State for the Confederacy, after being expelled from

school, returned on graduation and delivered a brilliant and powerful speech that brought rapt attention to his oratory. He supposedly made his remarks under a tree that became known as the "Toombs Oak." Some say Toombs never really left Athens, and much of the legend about him and the tree are apocryphal, but there is a state historical marker by the chapel on main campus claiming the Toombs legend as historical fact.

In 1976, Upshaw Bentley, Athens mayor, lobbied for a federal grant which resulted in a tree planting campaign for Athens. "It actually began when Julius Bishop was mayor," Bentley says. "We were able to expand on what Julius started." Today, downtown is blessed and refreshed with tree-shaded sidewalks just like the pedestrian thoroughfares throughout the University. Tree cover in Athens and on campus is a treasured commodity, easily seen from the tallest buildings in the community.

In 1891, the first garden club in America was founded, and the late Hubert Owens, internationally renowned for his work in landscaping and founder of the UGA School of Environmental Design, later landscaped the gardens at the Founders Memorial Garden in honor of this club.

With its ante-bellum homes, lush vegetation, and ample rainfall, Athens and the Georgia campus enjoy a fresh look most months of the year. Landscaping has been given great emphasis, and visitors to Athens marvel at the sheer beauty of the campus and the town.

In recent years the University has enjoyed increased financial support from state funding which has enabled it to realize its potential, but there have been some hallmark decisions which laid the foundation for the school to become one of the finest public universities in the nation.

Under the administration of Gov. Marvin E. Griffin, shaken by

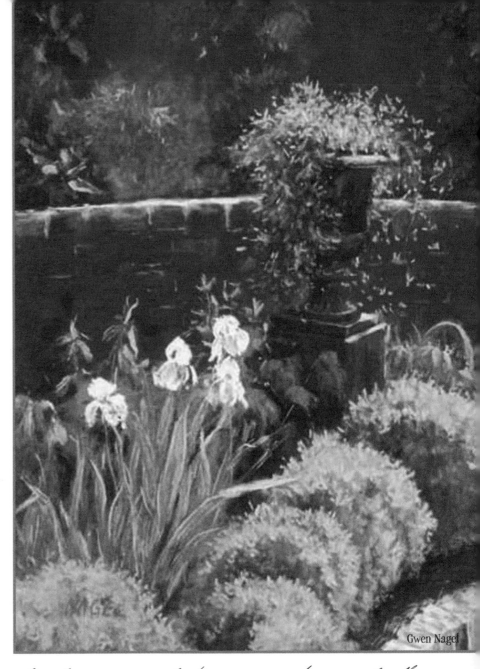

Gwen Nagel

On the campus of the University of Georgia, the Founders Memorial Garden is a two-and-a-half acre garden created as a tribute to the women who established the Ladies Garden Club of Athens in 1891, the first organization of its kind in the country.

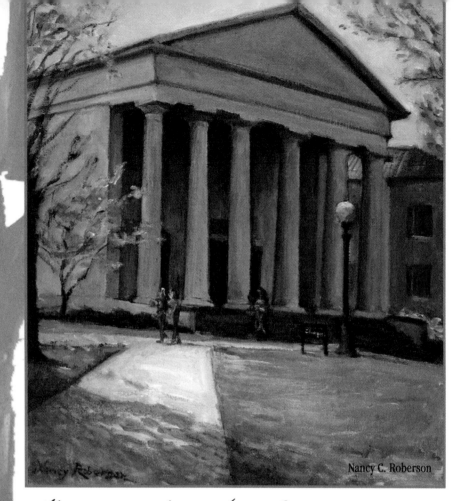

Nancy C. Roberson

This is one of the first Greek Revival structures built in Athens (1832). A bell, which signaled class periods, hung in a square cupola. The cupola was removed in 1913 to a wood tower behind the building. A huge painting of the interior of St. Peter's in Rome hangs inside the Chapel.

the Russian Sputnik orbiting the earth, funds were appropriated for the building of the Science Center on the South Campus. Those six buildings and later additions like the Pharmacy Building provided labs and facilities that enabled the University to recruit highly regarded faculty and provide a working environment that was exceptional.

That decision, coupled with funding which enabled the University to increase its faculty by fifty percent in one year, created a base from which the institution made a quantum leap forward.

The emphasis on education by a Georgia graduate, Gov. Carl Sanders, figured prominently into this heady and alacritous growth. Of telling significance was the vision of its youthful president, Fred C. Davison, who came on board in 1967. He enlarged on the building program set in motion by his predecessor, O. C. Aderhold.

A successor of Davison's, Henry King Stanford, though in office on an interim basis, used to say wherever he made speeches in the state, "Welcome to the campus of the University of Georgia." It was true; the campus of the state university is the state itself with programs and ties that stretch from Rabun Gap to Tybee Light, from Brasstown Bald to Hahira.

If you hark back to the founding days, it is stunning to realize that the University of Georgia has emerged into what it is today from those humble beginnings. A brush arbor was erected for the first graduation, which today has to be held outdoors in Sanford Stadium. That is the only facility on campus large enough to host an event which attracts up to 40,000 participants: graduates, faculty, family, guests, and friends.

Old College, the oldest building on campus, was built in 1806 and housed the entire university. The next building, New College, was completed in 1823. "Old College is the strongest link with the past," says Nash Boney. "It held the library, dining hall, and classrooms. It was also a dormitory."

North campus, which for the most part contained the original campus until the end of World War II, consisted of academic and administrative buildings in a compact and neat layout. It was tree-shaded, cozy, and convenient.

The South campus was physically linked to the North in the 1960s, when the Science Center was built and a bridge at the west end of Sanford Stadium physically joined the two campuses.

The biggest construction project came in 1929 prior to World War II when the original Sanford Stadium was built. For the bigger gate, Georgia played its arch rival, Georgia Tech, in Atlanta every year at Grant Field. Can you imagine playing your biggest game without ever having home field advantage?

Dr. Sanford organized an effort that led to the construction of one of the most beautiful stadiums in all of college football. One hundred alumni and friends of the University signed notes of $1,000 each guaranteeing the construction of the stadium. Georgia defeated Yale, 15-0, in the Dedicatory game on October 12, 1929, before 33,000 fans, including dignitaries (several governors and senators) from several sister states.

The notes were never called, and while there were times when balancing the athletic budget was a comprehensive challenge, the construction of the stadium on two natural hillsides with its gleaming hedges surrounding the field enabled Georgia to put itself into a position to compete with the best in college football.

In the late 1930s, owing to the Works Progress Administration and President Franklin Delano Roosevelt, who spent considerable time at Warm Springs for treatment of polio, numerous buildings went up on the campus in a notable building surge. It included the Fine Arts Auditorium, and Park, LeConte, Baldwin, and Snelling Halls. Several dormitories were also constructed as enrollment climbed past 3,000.

When America entered World War II, Athens was overrun with military, but the University was to benefit. Athens was the base for the Army Signal Corps School, and the Army took over many downtown buildings. The Navy preflight school, one of four or five in the country, dominated the campus landscape with 2,000 cadets marching about.

The Navy built Stegeman Hall, which was demolished a half century later. Named for athletic director, Herman J. Stegeman, it featured an Olympic-size swimming pool that provided Georgia an opportunity to develop successful swimming teams under B. W. Gabrielsen. However, it eventually became outdated and lost its usefulness. The swimming coach refrained from showing prospects the very facility where they would compete. The University now has a state-of-the-art natatorium in the Ramsey Center on the East campus that has resulted in multiple national championship trophies being collected.

During the 1950s, Athens' long time textile industries were joined by two firms of particular significance, General Time, which made clocks, and Westinghouse, producer of transformers. Later, Rhone Merieu, now Merial, manufacturer of veterinary vaccines, began in Athens. Merial is an example of new companies being formed out of UGA biotech and research programs brought about by the leadership of President Fred C. Davison. Nakaniski, a ball bearing producing company, came in the 1980s and White Cap, makers of caps for an assortment for liquid containers, chose to locate in Athens in the1990s.

Hanna Bat Rite Company, a firm that operated successfully from 1928 into the 1970s, produced bats for major league players, although after the war the company operated in the shadow of Hillerich and Bradsby in Louisville, Kentucky, makers of "Louisville Slugger" bats. The advent of the metal baseball bats caused the demise of the Hanna Bat Rite Company.

Of significance in present day Athens was the legalizing of

alcohol in the seventies, which paved the way for the opening of night clubs and led to the well established music scene from which sprang internationally regarded bands like the B-52s and R.E.M.

Tourism is the second largest industry in the state and in Athens alone the value of tourism is approaching $200 million. This brings about jobs and revenue, especially for hotels and restaurants. Annually, approximately 25,000 visitors come through the Athens Welcome Center, located in the historic Church Waddel Brumby House, the former home of Alonzo Church, who served the longest term as President of the University. It was also the home of Ann Wallis Brumby, the second Dean of Women at UGA and for whom Brumby Hall is named. Any visitor starting out here can graphically connect with the emphasis Athens and the University have placed on tradition but also an underscoring of progress and development that enhanced the quality of life and opportunity for the community.

The Athens Area Chamber of Commerce, founded in 1903, has been located at several addresses in the downtown area but moved into its new headquarters on Hancock Avenue in 2003, marking the celebration of "100 years of Business in Athens." The Chamber, longtime advocates of a harmonious blend of town and gown, is ever eager to spread the word and recruit visitors, business, and industry to a thriving community.

Clarke County was the second community in the state to use a state approved Special Purpose Local Option Sales Tax (SPLOST), leading to the building of the Classic Center and many fine public school buildings in the late 1980s. In 1989, voters approved a merger of city and county governments, the second community in the state to unify its governments.

When Atlanta won the bid to host the 1996 Olympics, lawyer Billy Payne, an All-Southeastern Conference end under Vince Dooley, was the ambitious leader who spearheaded the bid process and coordinated the events for the 100th anniversary of the staging of the games.

There was considerable sentiment to return the games to Athens, Greece, where it all began, but there were too many doubts about organization, funding, and infrastructure for the voting members, who gathered in Tokyo, to choose the ancient city as Olympic host.

Athens would be involved, however. Not Greece, but Georgia, where the nation's oldest chartered state university is located. Several competitions took place in Athens including volleyball, rhythmic gymnastics, men's preliminary soccer, and the finals of women's soccer. In order to meet dimension requirements for soccer competition, the famous and aging hedges, which needed replacing, were removed from Sanford Stadium and replaced with shoots (from the original hedges) which were nurtured and cultivated at various nurseries. Those shoots, fully matured, were installed in late summer following the Olympics to replace the original hedges.

In a thrilling championship soccer match, team USA (women's) defeated the national squad of the Republic of China, 2-1. This spectacular match, with a huge international TV audience, greatly stimulated interest in soccer in the Athens area, especially for women. One high-ranking European Olympic official lamented upon learning that he had been "farmed out" to purgatory when he

The 1996 Olympic Games brought international attention to Athens, Georgia when team USA women's soccer defeated the national squad of the Republic of China, 2-1, in the thrilling gold medal match seen world-wide by a huge international audience.

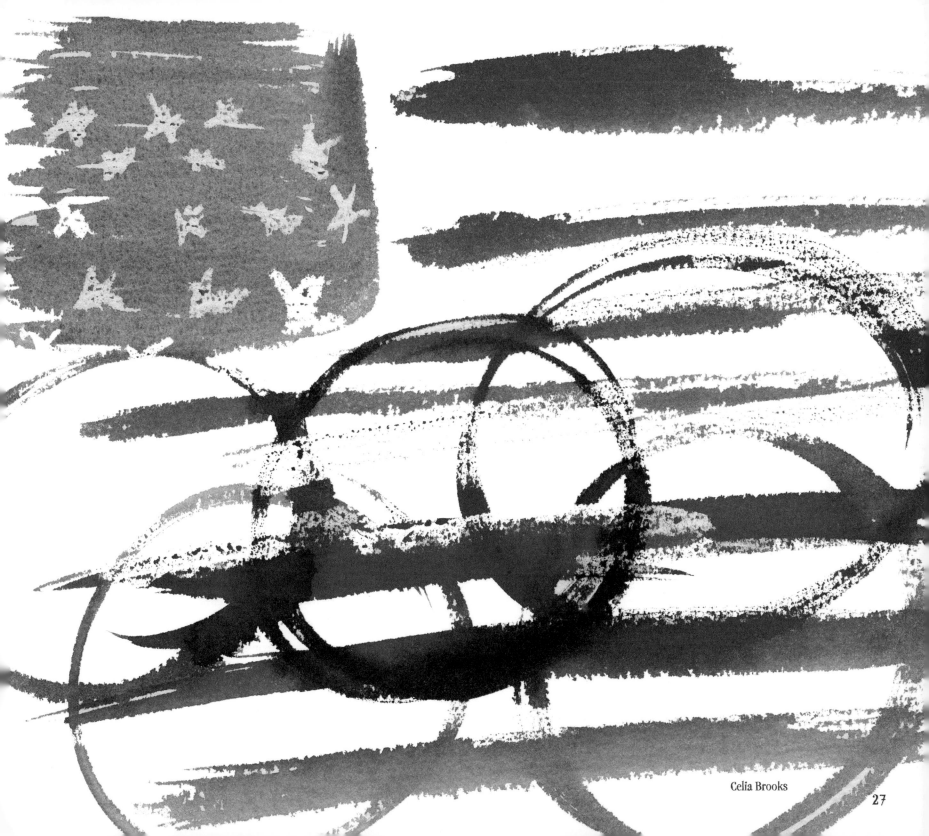

Celia Brooks

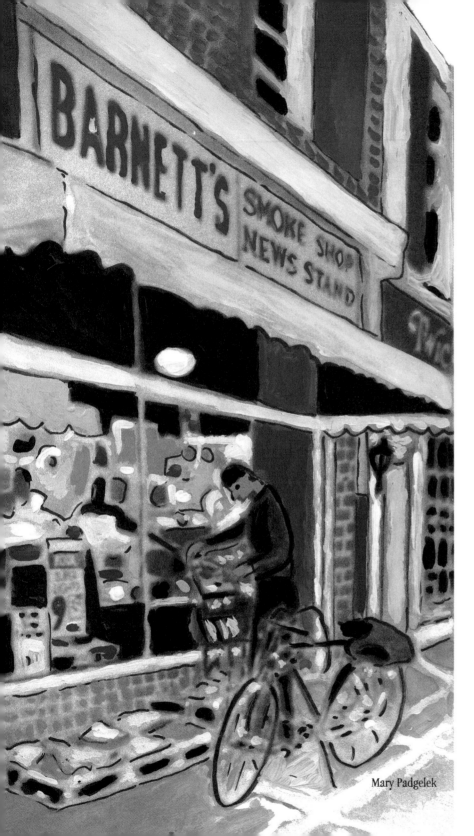

Mary Padgelek

Barnett's News Stand on College Ave., downtown Athens.

saw his assignment was in Athens. Afterwards he joyfully exclaimed, "Instead of being sent to purgatory, I was sent to heaven."

For years, Athens was a well kept secret when it came to beauty, livability and endless charm. But no more. While there is an accent on growth today, it still is a place where you can get across town without the choking traffic that dominates so many cities.

There are entertainment and cultural opportunities within a short drive to Atlanta if you avoid peak driving times, but there are plenty of options for similar activities and events in Athens.

The Twilight Criterion, an annual bicycle race which takes place downtown and attracts thousands, is an example of the special events appealing to younger citizens and students that have furthered Athens' reputation as a place of diversity, creativity, and excitement.

In addition to Bulldog football and other sports, there is the Georgia Museum of Art, which brings exhibitions featuring artists from Rembrandt to Matisse and Elaine deKooning.

Concerts with talented international artists are a staple of Athens' annual cultural calendar, both at acoustically perfect Hodgson Hall on campus and at the downtown Classic Center. The Athens Symphony appears frequently, along with occasional performances by the Atlanta Symphony. If a major attraction doesn't take place at Hodgson Hall, you might be pleasantly surprised at the talent offered by University theatrical productions.

For variety there are Broadway productions and performances taking place at the Classic Center, which has proven to be one of the most valuable assets brought about by tax funded assistance.

Building and expansion continues on campus, and nothing

showcases recent development like the Student Learning Center on Lumpkin Street. This high-tech facility, featuring classrooms, private study rooms, computer access, and research labs, draws students all hours of the day and night. It is one of the most popular and student-friendly buildings at UGA.

Nearby, there is a memorial to students and faculty who have given their lives in wars, a reminder that from the beginning there has been some link to a warring circumstance in this country. It has become tradition for the sheriff of Clarke County to lead the graduation procession, brandishing a huge sword. Unsubstantiated legend has it that in the early days the sword was used to keep Indians from attacking the students.

Downtown Athens is vibrant and uplifting. The sidewalk cafes bring about a European look. In the areas of Five Points, Prince Avenue, and Normaltown, there is a village influence and diners and shoppers are increasing with each passing year. On Saturdays you can find street markets downtown across from City Hall and at Big City Bread on Finley Street. Fresh fruits and vegetables, many organically grown, are in abundance. Vendors operate under a refreshing rule—if you don't grow it, you can't sell it.

On weekends the downtown atmosphere is electric, nightclubs offering music with aspiring bands hoping to get that jump into the big time like the B-52s and R.E.M.

If you prefer a less electric atmosphere, you can find it at the peaceful and inspirational Botanical Gardens south of town near the Whitehall community. The conservatory houses tropical and semitropical plants and serves as an outdoor laboratory for University classes. "It also offers short courses to the general public and is a model for such projects at other schools across the nation," says Nash Boney.

If you take a stroll down Broad Street at peak hours, you reflect on the busy and lively commotion in the vicinity of the University Arch, a replica of the one on the state seal, which advances the ideals of wisdom, justice, and moderation, the state motto. This is where town and gown graphically come together. It is a reminder that there has been, historically, a good and productive partnership between Athens and the University.

It is safe to say that the ancient Greeks would have approved of what this Athens has become. The town is a generously compatible partner with the University of Georgia, one of the most important higher education institutions in the country, a citadel of learning and culture in the rising hills of North Georgia.

Downtown

Even in the past, when the action was the noon rush hour at the Varsity at the corner of College and Broad on game day, downtown Athens has always been upbeat and inviting.

Why? Primarily the students, of course. If Ponce de Leon had come through Athens after World War II, he surely would have felt there was a fountain of youth located somewhere nearby.

Nothing has changed in the last half century in that regard except that there are more students now than ever in the past. They are attracted to the shops and restaurants. They stroll, read, and enjoy coffee under a canopy of beautiful trees, finding a bench where they can idle away or take a serious whack at something important in their educational pursuit.

Visitors find the charm and ambience of downtown alluring, too. They may venture across Broad Street to the tree-lined North

campus—dominated by oaks, magnolias, and ginkgos—where old buildings reflect tradition and heritage that can be found only where a majestic and advancing University exists.

There is more to the heart of downtown than College Square. The only known double-barrel cannon, a historical landmark that dates back to the Civil War, is often a backdrop for that memorable photograph. It stands peacefully on the lawn at the City Hall.

Want a short order meal? Try the Magnolia, the oldest downtown restaurant. Down-home cooking at its best! But there are fare options that range from Cajun to Italian to organic dishes to soul food to southern barbecue, all located within a five-minutes-or-less walk from the University Arch.

Check out the Civic Center and the historical fire station, which was preserved much to the delight of many local citizens. Feast your eyes on restored buildings and the traditional City Hall and Court House. Athenians do.

On Sunday after a night of partying, not everybody sleeps in. Athens is a city of beautiful churches with Greek columns and regal sanctuaries that beckon worshipers of all ages.

Landscaping has been given priority throughout Athens, and if traffic clogs the downtown thoroughfares, it usually means motorists have given way to a pretty coed who comes strolling across the street.

Drivers don't just stop to invoke courtesy. They are simply absorbing one of the many views that makes downtown Athens the place to be.

As a prominent hotel, the Franklin House served as one of the focal points for social and commercial activity in Athens until the Civil War. Today, it is a shining example of one of the first downtown commercial restoration projects.

Charlene Winterle Olson

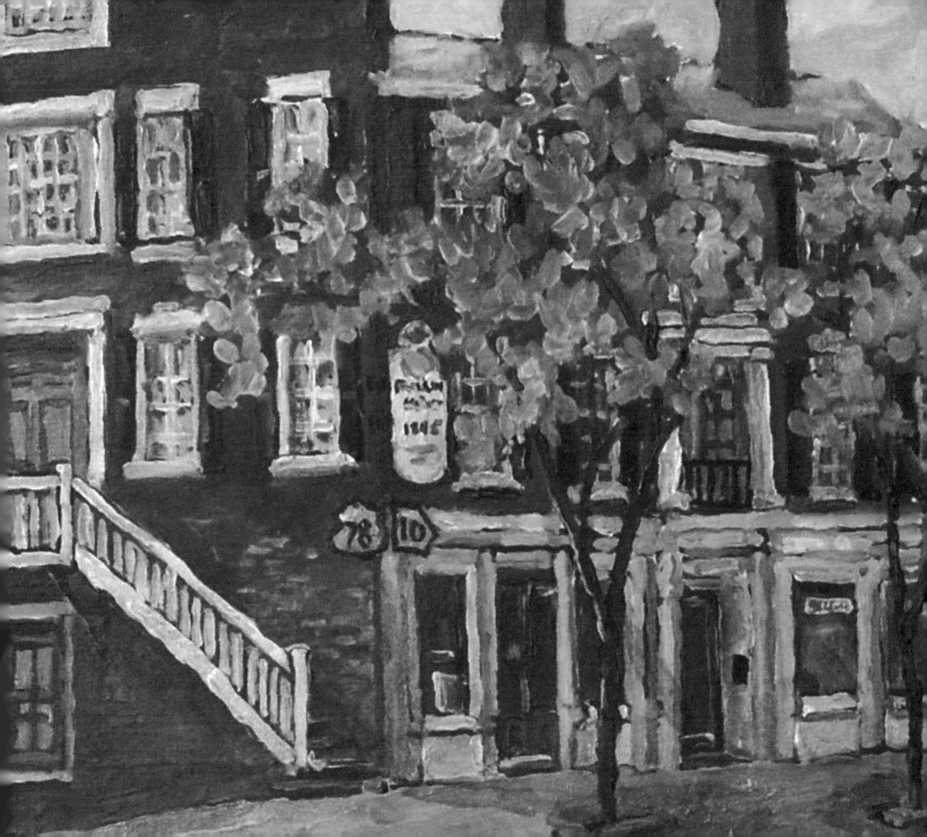

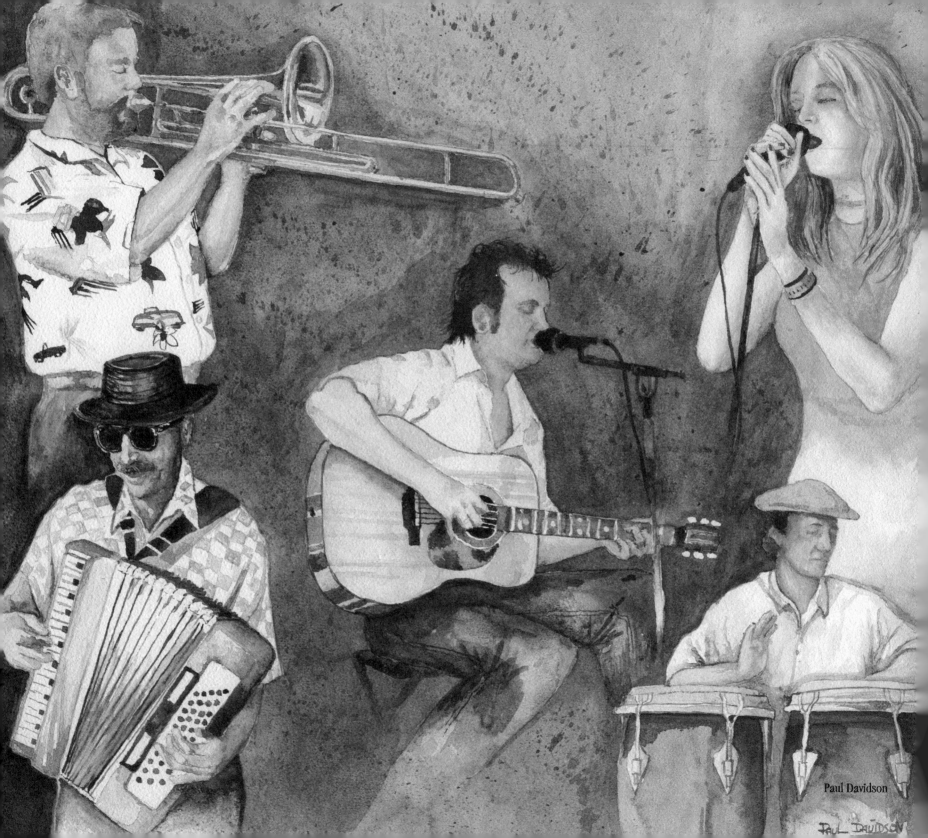

Paul Davidson

The Athfest Music Festival is one of the opportunities to hear great music. Many cafes in town can be cool places to listen to talent from the UGA campus.

Music

It all began—this musical phenomenon called R.E.M.—in April of 1980, the year the Georgia football team won the national collegiate championship.

That was also a very good year for Ronald Reagan. Elected President with the Hollywood movie industry on strike, he was the only actor with a job. "Genuine Risk" became the first filly to win the Kentucky Derby in sixty-five years.

Life was about to become golden for an unknown band when friends threw a birthday party for one Kathleen O'Brien, and an innocent and reluctant foursome of musicians—Bill Berry, Peter Buck, Mike Mills and Michael Stipe, stage fright overwhelming them—played before an audience for the first time.

Between three hundred and five hundred people showed up at a run-down church on Oconee Street. From that emotionally tantalizing and fulfilling start, the band that became known as R.E.M. would achieve international fame, often performing before crowds that exceeded 100,000. They have played in sold-out soccer stadiums across Europe, in ancient castles, the White House, Hyde Park, and, not insignificantly, intimate settings like the 40 Watt Club on West Washington Street and the Georgia Theater on Lumpkin Street.

R. E. M. has never forgotten its friends and its hometown. When members of the band, along with members of the U-2 group, performed for the Bill Clinton inauguration, that was nice. It was nice, too, when 80,000 showed up at Slane Castle near Dublin in the summer of '95, and 200,000 for a concert in Rio de Janerio, but it will always be heartwarming for this band to take the stage at the 40 Watt Club. Athens has always been and will always be the international address for R. E. M.

Lead singer, Michael Stipe, reflected on the band's auspicious beginning in 1980, when on the twentieth anniversary of the band's inception, he wrote the following for a fan club newsletter:

"We wrote fifteen songs in a month so we could play that thing. The party was wild. We expected about one hundred people and five hundred showed up. There weren't a lot of clubs to play in at that point and parties are real common in Athens, and it just kind of happened that we stayed together as a band and kept playing. Peter remembers that, 'We got drunk and fell off the stage. Michael burned himself with a cigarette real bad, we smashed up a bunch of equipment. Yeah, it was real fun.' The rest, as they say, is history. And, oh yeah, the group did decide upon a name. After playing their first show still nameless, the band had a brain-storming session and emerged with a winner from a shortlist that included 'Twisted Kites,' 'Slug Box,' 'The Ninth Wave,' and 'Cans of Piss.' R.E.M. was chosen as a result of an evening of 'flip-and-point' with the dictionary. As Peter noted in 1982, 'In the beginning when we started together, we didn't know what kind of music we would be playing. We didn't want to limit ourselves by calling the band 'Punk Rock' or something. R.E.M. was perfect—real non-descriptive.' "

However, the first band from Athens to hit the big time was the B-52s. Its members organized in the late 1970s, set up shop in New York, and the band was an instant hit. Though Manhattan remains its business address, the B-52s, like R. E. M., maintain close ties with Athens. The band frequently returns to perform—even in the small, intimate theaters like Tasty World, Caledonia Lounge, Georgia Theater, and, of course, the 40 Watt Club.

At the outset, musicians had begun to congregate in Athens, but there was no defining reason. "It was one of those things that just happens," says Bertis Downs, manager and lawyer for R.E.M. "Where there is a college town, there is energy, creativity, and an appreciation for good music and entertainment. Happily, there is simply something special about Athens, and artists realize that right away."

After the B-52s and R. E. M. gained traction, Widespread Panic, Love Tractor, and Pylon joined the hit parade in the 1980s. Bands kept gathering, organizing and performing in Athens right on into the 1990s when Elf Power, Olivia Tremor Control, and Neutral Milk Hotels gained star power.

By the start of the twenty-first century, there were over 400 bands in Athens—serious performers with talent who had gained widespread respect and appeal. Not many are likely to make it big like the B-52s and R. E. M., but in all likelihood there will be another sensational success story. "Just too much talent and too many artists for it not to happen," Downs says.

With the preponderance of bands on the local scene, music significantly contributes to the economy. Like a magnet, the music scene draws people from everywhere. Guitar shops and stores for musical instruments have opened with regularity and so have recording studios that attract artists who stay for days and weeks renting hotel rooms and paying travel expenses. Bars, restaurants, and night clubs have proliferated. With Athens becoming a popular gathering place, music stimulates tourism. Professional services are required—legal, accounting—to say nothing of housing and transportation.

You may not know Jim "Bones" Mackay, but his story reflects the impact the Athens music scene enjoys regionally and nationally. He is the longtime caddie for 2004 Masters champion and 2005 PGA champion, Phil Mickelson. Bones settled in Athens because of his great love for music.

He introduced Mickelson to R. E. M. and Mickelson became a fan. Mickelson in turn introduced several PGA pros, including Davis Love and Fred Couples, to R.E.M. Mickelson has become a fan of Athens, the Athens Country Club, and the University golf facility in the process. He says that his favorite place for breakfast in the entire country is the Waffle House in Five Points. "We don't have Waffle Houses out West, but we wish we did," says Mickelson's wife, Amy. When in Athens, Mickelson's preference for dinner is the Five & Ten.

There are other examples of music bringing celebrities and Athens together. Many slip in quietly unannounced for a weekend and depart as incognito as they arrived. What is the value of the music industry to Athens? Downs has never seen any figures, but concludes that it has to be in the millions.

"The good news," Downs says, "is that it is still growing. There is more interest in the music business in Athens than ever. It is a great asset for a city that has a great appreciation for culture, artists, and creativity."

Originally a night club that attracted nationally touring performers such as Boz Scaggs and Steve Martin, the Last Resort is now a restaurant.

Jamie Calkin

© 2002 Jamie Calkin

John C. Ahee

A colorful rendering of the beloved Georgia mascot, Uga.

UGA Atheltics

The Georgia "G" represents a national symbol when it comes to college athletics, much of the attention and hype owing to the success of the football team. College football fans across America know about the Dawgs.

However, notable success in sports other than football takes place at UGA annually. While football is the backbone of the Georgia athletic program, there is a championship atmosphere that permeates the entire athletic program.

Each team recruits with an accent on winning championships, and a quick review confirms that national titles—sometimes multiple—have been won in baseball, equestrian, gymnastics, and in men's and women's golf, tennis, and swimming.

Individual national titles have also been claimed by Bulldog athletes, and dozens of competitors schooled in Athens enjoy Olympic medal-grabbing opportunity.

Georgia has one of the most successful overall athletic programs in the NCAA. Of particular note is the high achievement of the women's programs. UGA got out front early with budget support and facility development under the leadership of former athletic director, Vince Dooley. As a result, women's teams have been eminently successful recruiting on the national—even international—level.

Men's basketball is gaining ground in the rugged Southeastern Conference, one of the toughest in college basketball. Basketball in the SEC has improved considerably, and Georgia is recruiting talent with a passion and ambition that makes the future attractive for Stegeman Coliseum.

Lady Dog basketball annually distinguishes itself in SEC and NCAA competition, winning tournaments and championships and attracting some of the best talent in the country.

Football remains the focal point of Bulldog athletics and has gained national recognition since the dedication of Sanford Stadium in 1929. Of course, there have been some off years, but there have also been eleven SEC titles and five national championships.

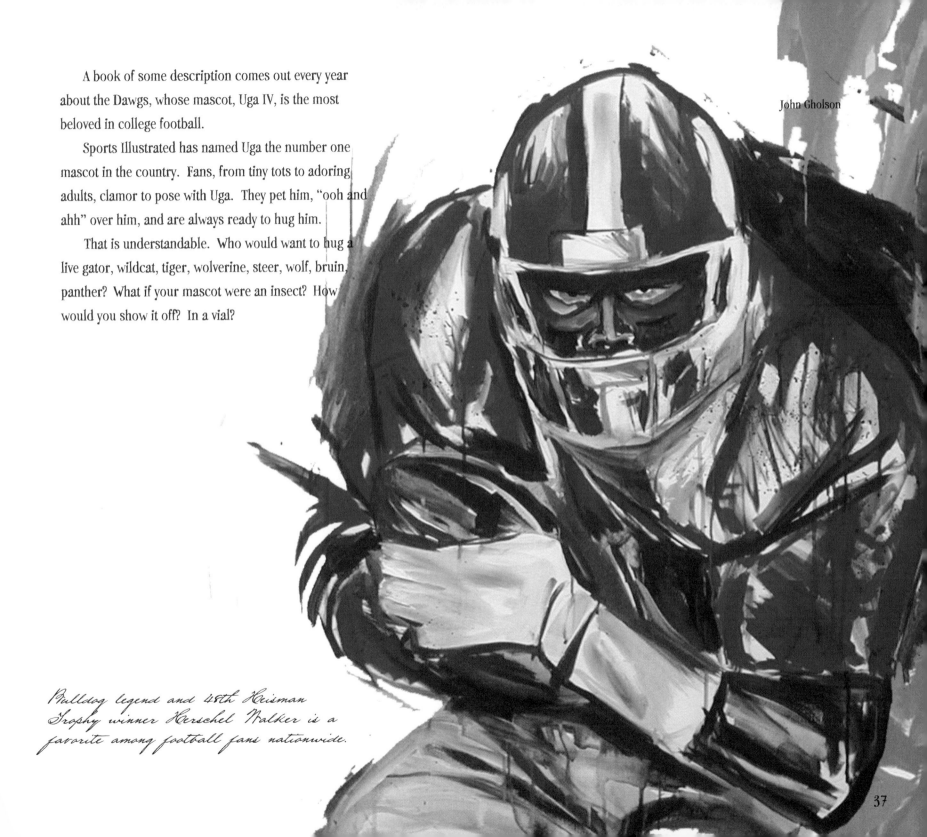

A book of some description comes out every year about the Dawgs, whose mascot, Uga IV, is the most beloved in college football.

Sports Illustrated has named Uga the number one mascot in the country. Fans, from tiny tots to adoring adults, clamor to pose with Uga. They pet him, "ooh and ahh" over him, and are always ready to hug him.

That is understandable. Who would want to hug a live gator, wildcat, tiger, wolverine, steer, wolf, bruin, panther? What if your mascot were an insect? How would you show it off? In a vial?

John Gholson

Bulldog legend and 48th Heisman Trophy winner Herschel Walker is a favorite among football fans nationwide.

37

Athens Contemporary Art Scene

---The contemporary art scene in Athens, Georgia, according to artist Jim Herbert, is so rich and diverse because, "...people are not thinking about taking their work to New York or taking it here or there, but rather they are thinking about the practice of doing art, the making of art. They are concerned with the dignity of making, the fun of making."

The singular mark of art produced in Athens is the overwhelming quality of the work. Visitors to Athens often comment about this and about the proliferation of art in so many public places – from coffeehouses to hair salons to restaurants. Whether the work is representational or abstract, traditional or cutting edge, quality and a sense of purpose infuse the product.

Many reasons have been suggested over the years for this abiding quality. The inspiring physical beauty of the natural surroundings in Athens; the presence of the Lamar Dodd School of Art; the critical mass of musicians, writers, dancers, and creative people working in all media; as well as the low cost of living in Athens have been cited as factors. While all of these factors are certainly very important to the creative development of the community, it is a far more accurate assessment to say that the drive, the desire to make art for art's sake, is responsible for the fertile art scene found in Athens.

Visitors to Athens (as well as many natives) struggle to verbalize what it is they are seeing when they recognize a work of art as having the special attributes that make it Athenian. Herbert's explanation for the depth of visual art produced in Athens rings true with most people because it provides an explanation for the honesty found in most works that bear the hallmark of the community, which is perhaps the best explanation for the quality of the Athens contemporary art scene.

Just because people make art for the "joy of the making" as Herbert says, hasn't stopped the larger art community around the nation from recognizing the talents of our best and brightest. Herbert in particular stands out nationally as one of very few people to ever be awarded two grants from the John Simon Guggenheim Memorial Foundation in different disciplines. He has also had five one-person exhibitions at the Museum of Modern Art (MOMA), a rare feat among artists. Herbert has been recognized in two disciplines: painting and filmmaking. His filmmaking has reached popular audiences through the twelve videos he directed for local musicians R.E.M., but art lovers know him as much for that as for his large scale expressionist paintings, which average twelve by twelve feet in size.

While not every professional artist in Athens attended or taught at the University of Georgia's Lamar Dodd School of Art, it is impossible to deny the importance of the school to the development of the creative community. Athens' history is inexorably linked to the University of Georgia and it has infused all aspects of the community, in particular the creative community.

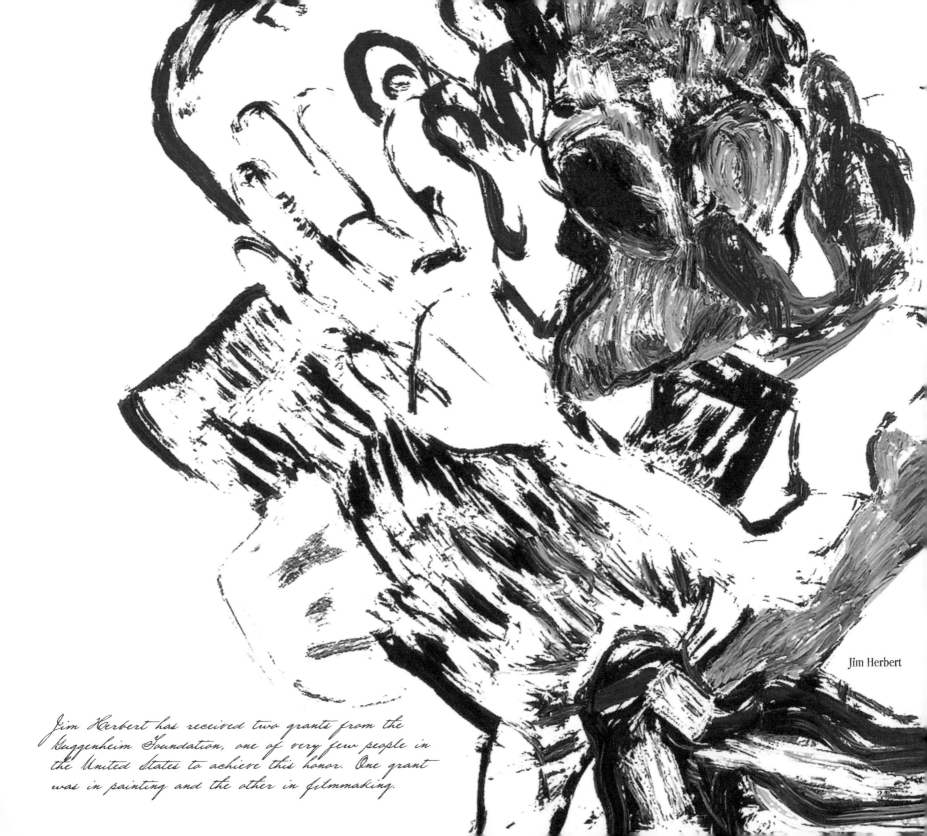

Jim Herbert has received two grants from the
Guggenheim Foundation, one of very few people in
the United States to achieve this honor. One grant
was in painting and the other in filmmaking.

Jim Herbert

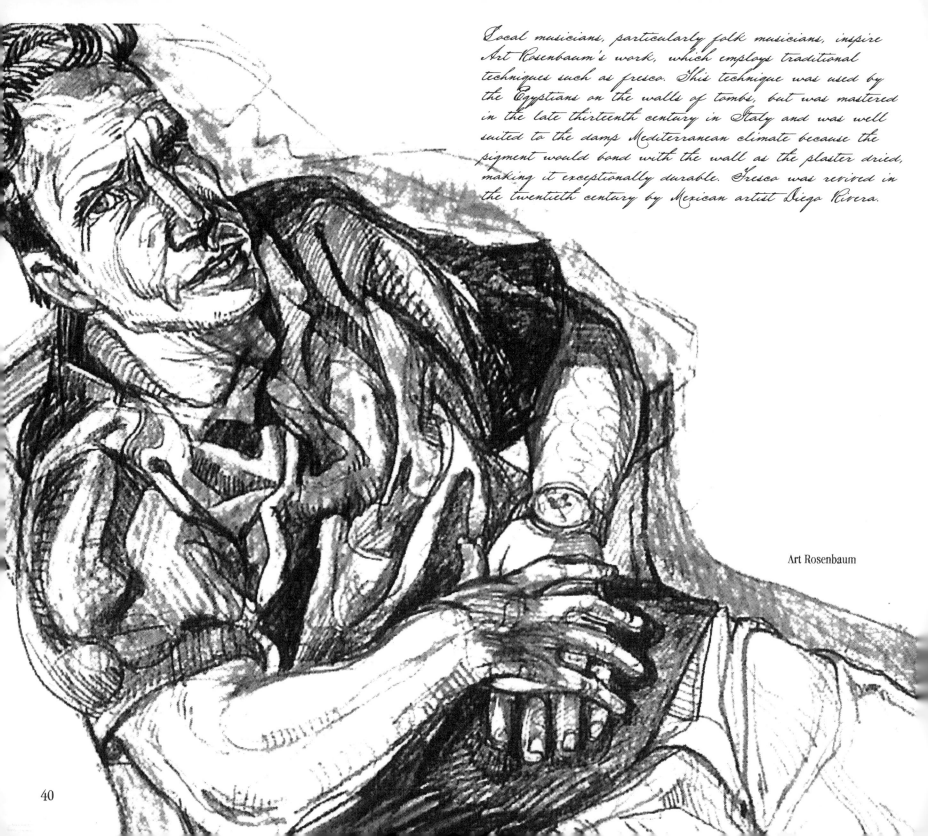

Local musicians, particularly folk musicians, inspire Art Rosenbaum's work, which employs traditional techniques such as fresco. This technique was used by the Egyptians on the walls of tombs, but was mastered in the late thirteenth century in Italy and was well suited to the damp Mediterranean climate because the pigment would bond with the wall as the plaster dried, making it exceptionally durable. Fresco was revived in the twentieth century by Mexican artist Diego Rivera.

Art Rosenbaum

40

The art school at UGA was founded in 1937 and was run by Lamar Dodd until his retirement in 1972. Dodd achieved prominence in the art world during the 1920s and 1930s after traveling to New York City to study at the Art Students League. The Ashcan school and American Scene artists such as Thomas Hart Benton influenced him. The Ashcan school's philosophy of painting everyday scenes merged with the American Scene doctrine of nativist art and Dodd became a vocal proponent of "local art." He also brought a new level of excellence to art education in the state of Georgia. During the 1960s and 1970s, a generation of professors was hired at the University of Georgia who have come to symbolize the level of quality and excellence that marks the body of work produced in Athens.

To narrow the list of people who have shaped the creative community in Athens is exceedingly difficult. Athens is a social town and much of the vibrancy here is a result of people coming together to discuss the progress of their work, to seek out invigorating collaborations, and to get inspiration from numerous sources. In that regard, it could be said that almost every artist living and working here is an influence on the contemporary art scene.

There are five extraordinary professionals who deserve to be highlighted for the magnitude of their impact on the creative community in Athens, Georgia. They are Art Rosenbaum, Richard Olsen, Judith McWillie, Jack Kehoe, and Jim Herbert. It would be difficult to find an artist living and working in Athens who doesn't list at least one, if not more, of these five as a profound and abiding influence on their creative development. Most artists in Athens have drawn inspiration in one way or another from

members of this group at the Lamar Dodd School of Art.

The Lamar Dodd School of Art is a very traditional program, yet one that encourages tremendous exploration. The curriculum is grounded in a classical figure-based art education. Students are required to take a core curriculum composed of drawing and design fundamentals before they can move into advanced pursuits. Following this traditional foundation program, students have the option to explore all contemporary art media. This approach is grounded in the belief that you must know the rules before you can break them, or as some say, "you have to learn to walk before you can run."

The genesis of a more contemporary approach to art education took place during Lamar Dodd's tenure at the university. Programs such as the highly unorthodox Art in the Dark, where students responded to the projection of color forms and shapes in a darkened environment, sought to broaden the creative development of young artists. Today, the digital media program at the Dodd School carries this inventive way of thinking into the twenty-first century.

Art Rosenbaum

Art Rosenbaum is a great example of an accomplished painter with a traditional background who makes use of technology to create contemporary historical scenes, not unlike artists of the High Renaissance in seventeenth century Italy. A modern Tintoretto of sorts, Rosenbaum crafts elaborately constructed figurative compositions recounting the lives of local musicians, artists, and townspeople. Rosenbaum has done extensive research

into the traditional techniques practiced by artists from the beginning of time. He has passed along many of these forgotten secrets to students in a class about traditional media. In particular, the techniques of fresco, encaustic, egg tempera, and traditional oil glazing introduce young artists to the ways of the past. It would not be at all out of place in his mind, however, to encourage a student to generate a composition through the use of photo or digital media and then execute that work in the oldest of all known art processes: fresco.

Rosenbaum's influence on contemporary artists showing in Athens today is seen in the work of Dennis Harper. Harper's very modern compositions are executed primarily in egg tempera and defined by their use of traditional media. Harper often paints contemporary updates to early Renaissance scenes. A typical painting (if such exists) might include a father and son in a brightly colored living room watching a bird fly out of a lit fireplace. One series of drawings depicts a formal Italian landscape, but is inhabited by robots from outer space. In this way, Harper uses the lessons of art history by employing the techniques and materials of the past, while advancing his work through images that are informed by his very modern, personal experience.

Richard Olsen

Another artist who has forged a unique creative approach through a blending of traditional techniques and cutting edge contemporary thinking is Richard Olsen. Olsen focuses his teaching on color theory. His philosophy of 2 + 2 = 5 encourages students to think beyond societal norms and to produce work that is contrary to any

Dennis Harper

Dennis Harper, a student of Rosenbaum, uses egg tempera to render his modern compositions. Egg tempera is made by mixing pigment with raw egg and water. It predates oil paint and was discarded in favor of oils because it would disintegrate when worked or blended.

expectation. He frequently says, "think of the colors people would expect you to use or consider pretty and then do the opposite." Like Rosenbaum, Olsen requires that students obtain a complete knowledge of the relationship between colors in order to transcend these basic optical effects. The radical nature of his approach lies in his desire to draw out artists'

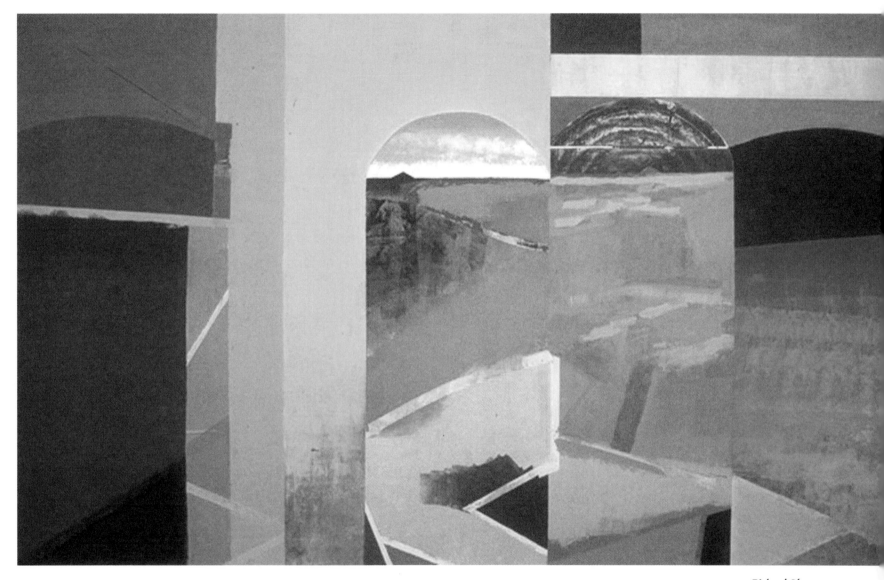

Richard Olsen

Any composition that depicts objects in a way that subordinates or discards their "realistic" appearance is considered abstract. Abstract art frequently breaks down the shapes, forms, lines, and colors to such a basic level as to be unrecognizable or almost unrecognizable. This painting by Richard Olsen, Wall CXLIV, represents the 144th in a series of images of the wall of his studio.

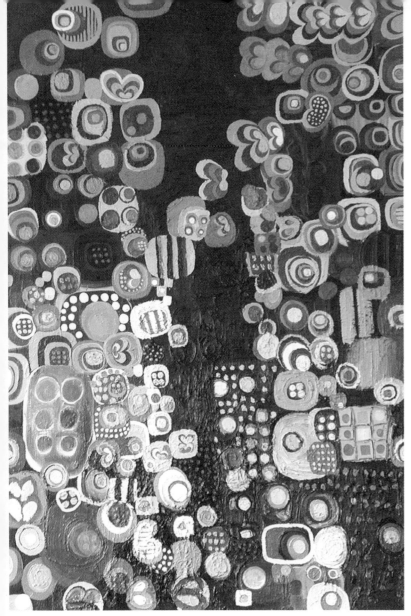

Hannah Jones

Hannah Jones uses form and color to create abstract paintings that use "a language of visual symbols to illustrate connections, communications, and universal behaviors."

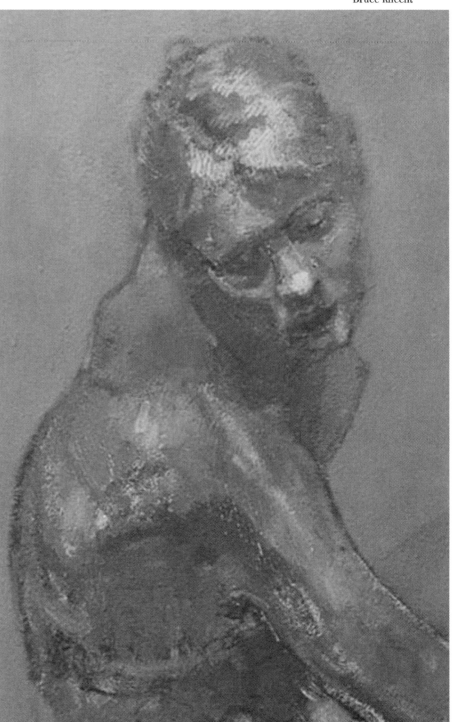

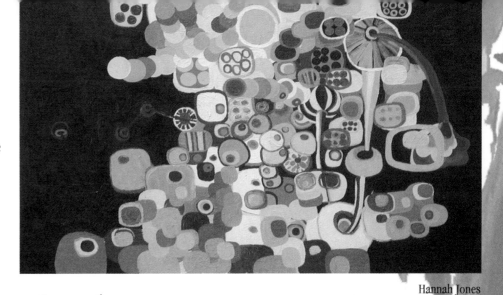

Hannah Jones

connections to their deepest subconscious point of reference. In a class titled, "Scheme and Calculation," Olsen delves into the age-old question of who we all are and where we are from. By recognizing where they come from, however that is defined, the artists are able to communicate honestly.

Artwork produced by Olsen's students is marked by this honesty. Bruce Knecht and Hannah Jones are examples of this phenomenon. Knecht's and Jones's compositions are not trying to be part of any particular style or fashion in the art world. Rather they are clear expressions of the way these two artists see the world from their unique perspectives. Knecht is best known for his ethereal figure paintings, which are defined by a muted, subtle palette and baroque composition. Conversely, Jones is an abstract painter who uses color to create a harmonic world of personal landscapes. As a musician and painter, Jones has developed a language of shape and form that is lyrical.

Hannah Jones's artwork evolves along with and through the idea of abstract and "invisible" forms of communication. She allows her pieces to take shape in an intuitive way.

Judith McWillie

Judith McWillie is another important Athens artist who has influenced students over the years. Drawing inspiration from untrained artists, McWillie encourages students to seek perfection in their craft in order to be able to act intuitively. A writer and visual artist, she has documented the lives and work of numerous Southern "Outsider artists" such as J.B. Murry, Howard Finster, and R.A. Miller. Outsider art—known to some as folk

art—is best defined by the fact that the artist has never studied art formally. Additionally, many outsider artists use basic primary colors, unusual materials and media, and narrative explanations in their artwork. Many self-taught artists are laborers who were inspired to make art out of their passion to create outside of any artistic motivation or history. McWillie's paintings have a remarkable freedom and vibrant purity that grow out of her connection to the intuitive artists she has studied and discovered. Her influence is best seen in the newer generation of Athens artists through the frequent use of narrative, mixed media, and simple forms. One artist in particular, Jeff Owens, has adapted the use of traditional oil techniques to the creation of fantastical paintings based on his childhood fascination with album cover art and comic books.

John D. Kehoe

One of the most influential elements of the contemporary Athens art scene isn't in Athens at all, but rather in Cortona, Italy. John D. (Jack) Kehoe, a sculptor who works in marble and stone, has impacted several generations of artists in Athens since founding the Cortona Studies Abroad program in 1970. The Cortona program began with a very small group of students traveling during the summer thirty-five years ago to take basic art classes and has grown to a full program of art, landscape architecture, and Italian culture and language with about two hundred students per semester. The Athens artists who have benefited from this program are too numerous to list, but their experiences are visible in their artwork through clues such as the use of the Italian landscape in their compositions.

Terry Rowlett, a popular realist painter who has worked in Athens for more than 15 years, frequently uses cedar trees and red roofed houses in his modern interpretations of biblical and iconic historical stories. Rowlett features local artists and musicians in his updated classical compositions. His work has been shown in national exhibitions and publications including *Harper's Bazaar* and the *Oxford American*. Two series he is known for are his motorcycle paintings and levitating people. His work is defined by magical realism and classical influences.

Jack Kehoe has exhibited internationally for many years and his large-scale marble carvings have challenged young sculptors at the University, as well as bringing wider attention to the program. In fact, many artists living and working in Athens today came to the University for graduate study after being exposed to the Dodd School through the Cortona Program.

Jeff Owens

Inspired by the comic books and album covers of his youth, Jeff Owens uses traditional techniques, such as oil painting, to create fantastical paintings.

Terry Rowlett's work is influenced by many things, including his experiences studying in Cortona, Italy. The cedar trees in this painting recall the familiar Tuscan landscape.

Terry Rowlett

47

Automatic painting is the act of beginning a painting with no thought given to subject matter or composition. Jim Herbert paints large-scale works with his hands rather than brushes and frequently employs automatic painting to achieve subconscious explorations of primal themes.

Jim Herbert, who is known to many for his films and the twelve videos he directed for Athens band R.E.M., is also a major influence on many artists living and working in Athens today.

Jim Herbert

Jim Herbert

Chris Wyrick

Painter and filmmaker Jim Herbert has taken advantage of the Cortona Program and the Italian connection by working with students to create films in Italy since 1994. What Herbert found there was a new freedom for himself as an artist and his students to capture the contemporary landscape often overlooked in America. As a teacher, Herbert's primary impulse is similar to McWillie's—to encourage students to create from an intuitive mind frame. Like the other artists mentioned, Herbert has a deep respect for knowledge of traditional techniques, though with an equal desire to surprise and challenge the status quo. He uses "automatic painting" in his own work, painting with his hands with no forethought as to the subject matter or composition. This results in subconscious explorations of primal themes. Students who have worked with Herbert quickly find themselves transcending expectations and getting to the core of themselves and their work.

Chris Wyrick came to Athens for graduate study after attending the Cortona Program in 1994 and working with Herbert there. Wyrick had studied the Old Masters extensively and thought his primary interest was in bold compositions learned from this education. Herbert, however, saw more honesty and more power in a simple drawing of a cow at the University dairy farm found in the corner of Wyrick's studio. This led to a series of simple, direct, plein air animal paintings that still informs his work a decade later.

The contemporary art scene in Athens is a rich collection of artwork and artists who take such joy in their chosen profession that it is obvious to the viewer. Often juxtaposing traditional techniques with modern themes and subject matter, Athens artists frequently surprise and delight their audience. Though Athens has long been known as a music town, the impact of the visual arts is also well known and will continue to grow.

Plein air painting, from the French for "open air," refers to paintings created outside. Some of the best-known plein air works were created by Claude Monet (1840-1926) and Pierre-Auguste Renoir (1841-1919) during the Impressionist movement. Chris Wyrick makes plein air paintings in order to capture the movement of his subjects, as in this large-scale work depicting the birth of a calf.

Jim Herbert

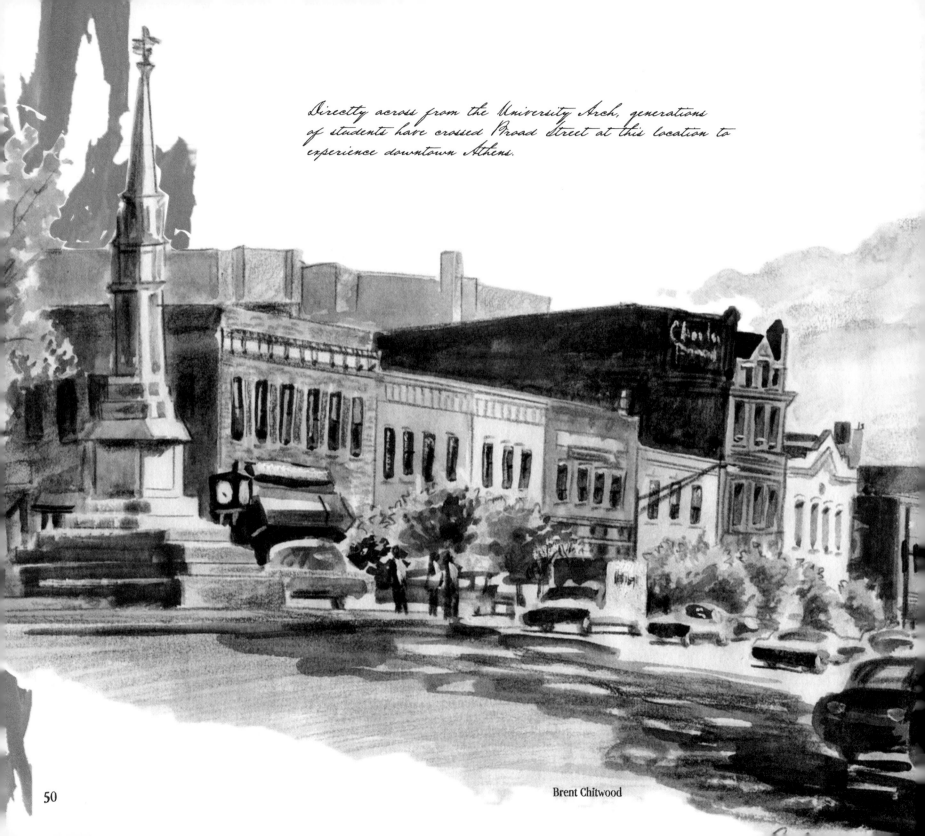

Directly across from the University Arch, generations of students have crossed Broad Street at this location to experience downtown Athens.

Brent Chitwood

50

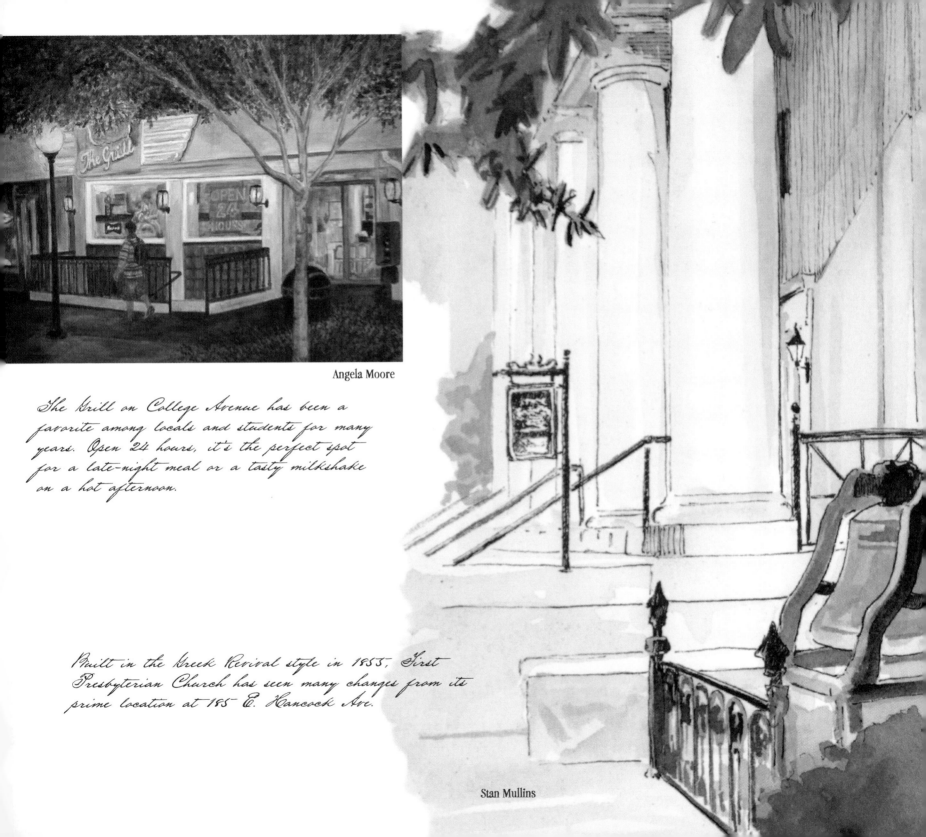

Angela Moore

The Grill on College Avenue has been a favorite among locals and students for many years. Open 24 hours, it's the perfect spot for a late-night meal or a tasty milkshake on a hot afternoon.

Built in the Greek Revival style in 1855, First Presbyterian Church has seen many changes from its prime location at 185 E. Hancock Ave.

Stan Mullins

Broad Street eateries such as the Mayflower and Gyro Wrap show the diversity of downtown restaurants.

Chris Cook

Located directly outside the famous UGA arches, College Ave. at Broad St. is a hotspot for activity. Students looking for a cup of coffee or a bit of downtime can find it there.

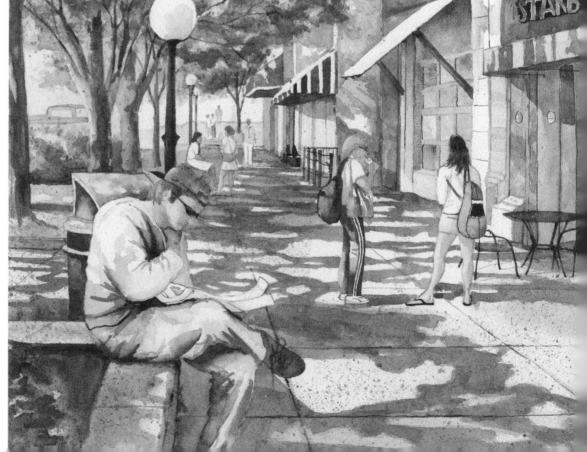

Paul Davidson

Chris Wyrick

One of the oldest homes in Athens, the Judge Lumpkin House at 248 Prince Ave., is listed on the National Register of Historic Places. Now owned by the Joseph Henry Lumpkin Foundation, the house is used for small meetings and seminars.

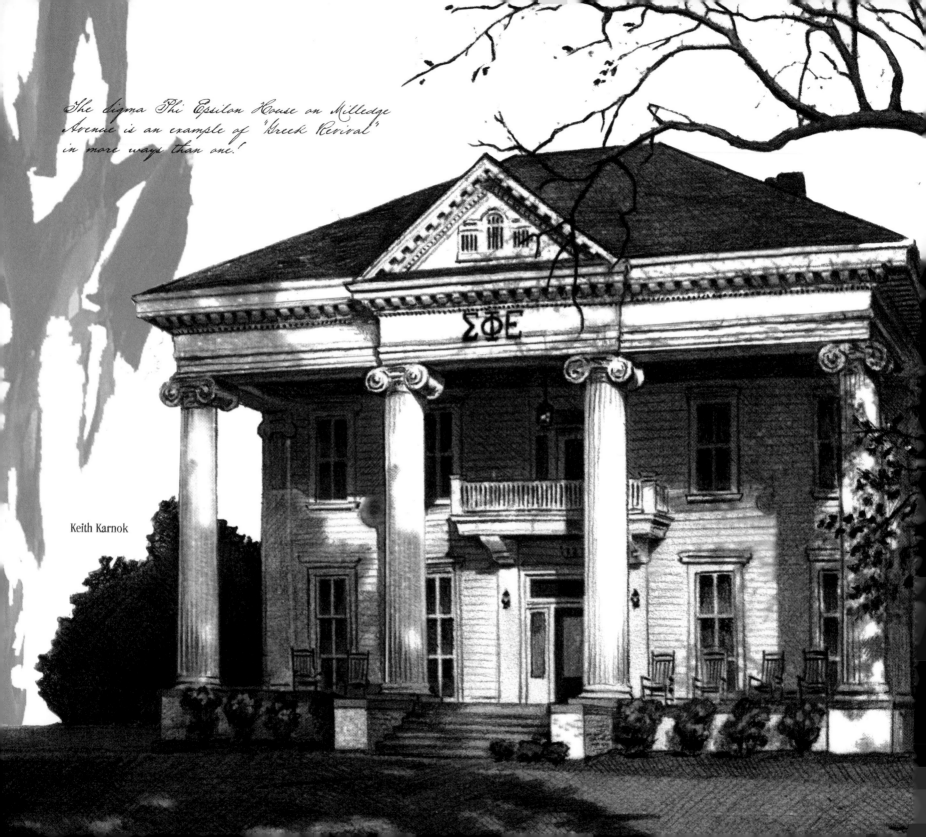

The Sigma Phi Epsilon House on Milledge
Avenue is an example of "Greek Revival"
in more ways than one.!

ΣΦΕ

Keith Karnok

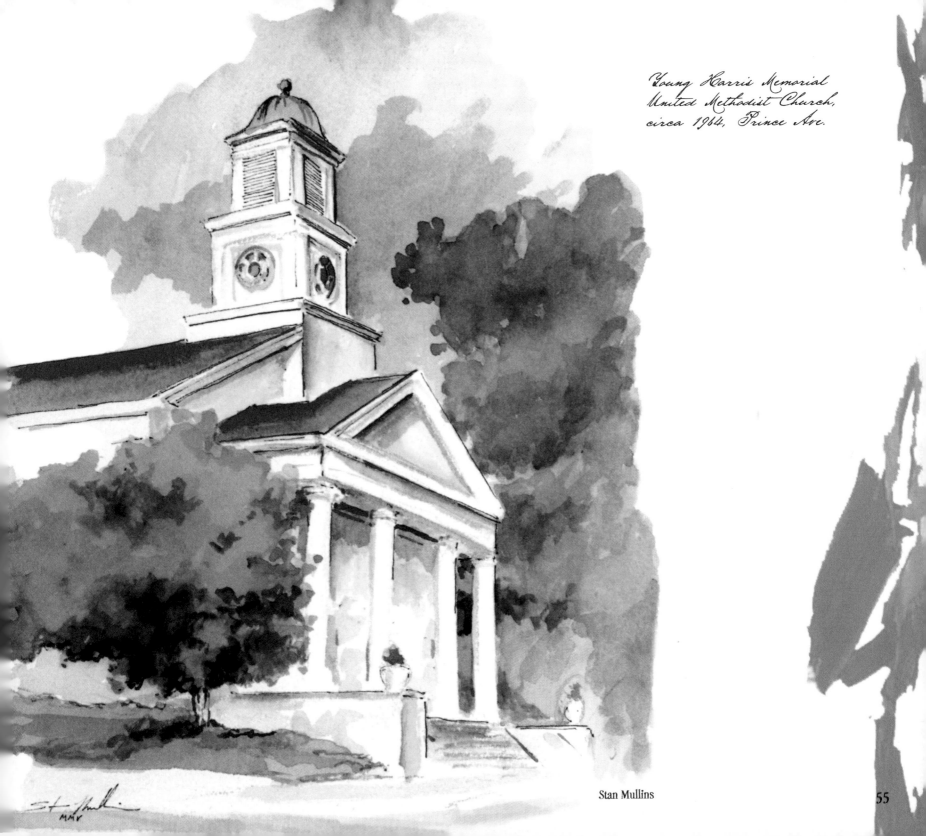

Young Harris Memorial
United Methodist Church,
circa 1964, Prince Ave.

Stan Mullins

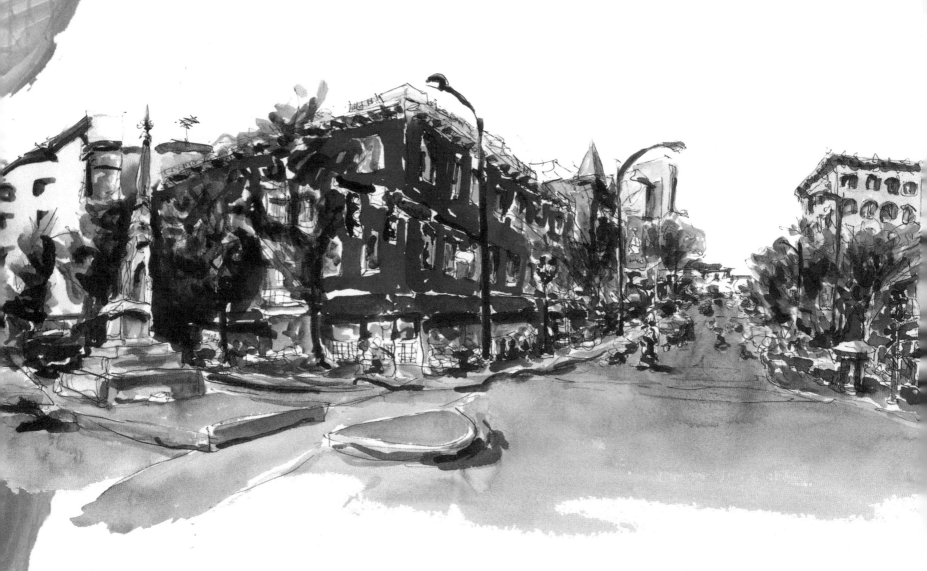

A classic view of downtown Athens enjoyed by residents, visitors, and students alike.

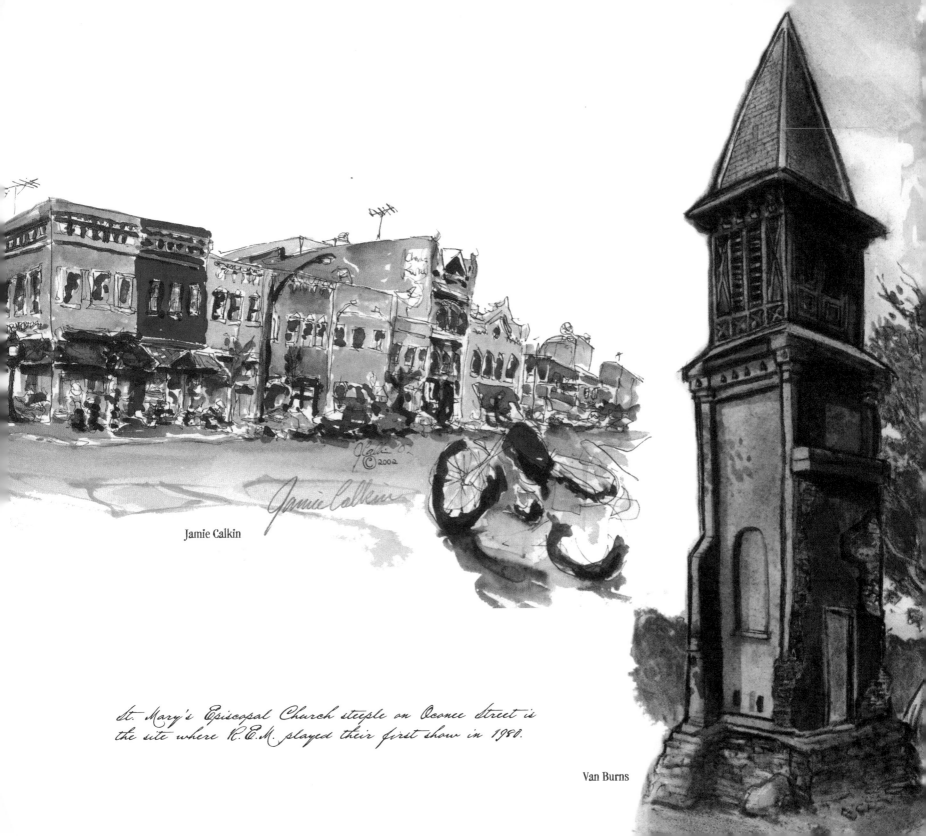

Jamie Calkin

St. Mary's Episcopal Church steeple on Oconee Street is
the site where R.E.M. played their first show in 1980.

Van Burns

Many a juror took a lunch break at Strickland's Restaurant, once a Broad Street staple.

Mary Padgelek

Uncle Alberts vintage clothing
serves the eclectic tastes of
students and locals.

Angela Moore

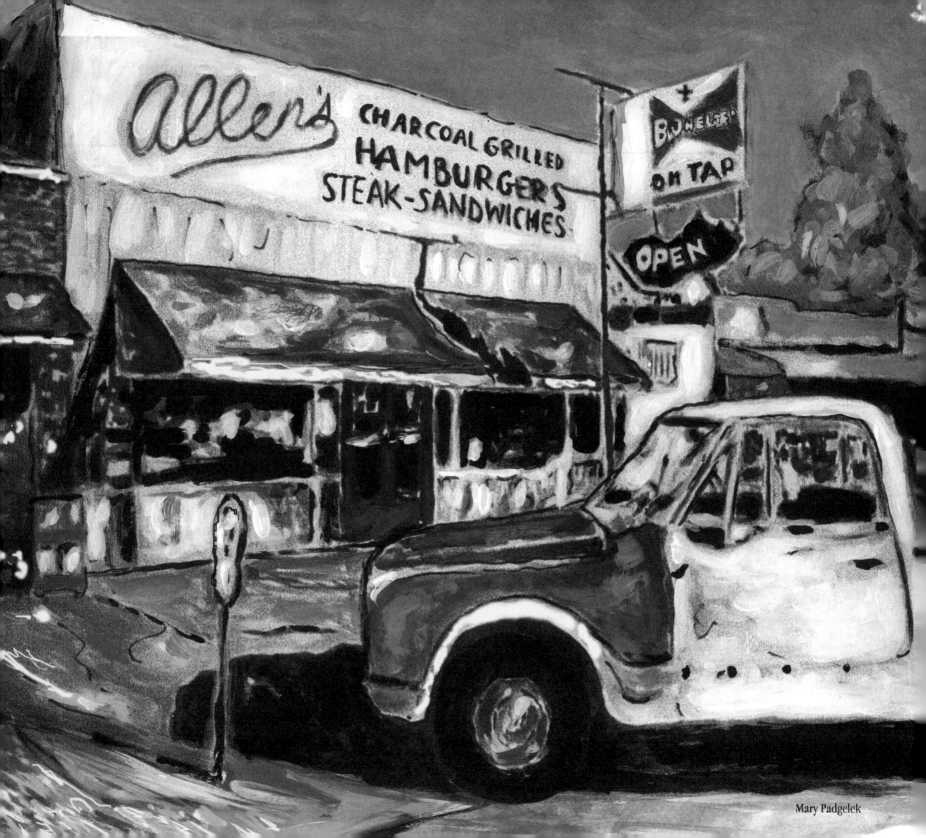

If these walls could talk, Allen's, a favorite hangout in Normaltown, would reveal tales of notable Georgians from across the state. Sadly, the legend ended New Years' Day 2003.

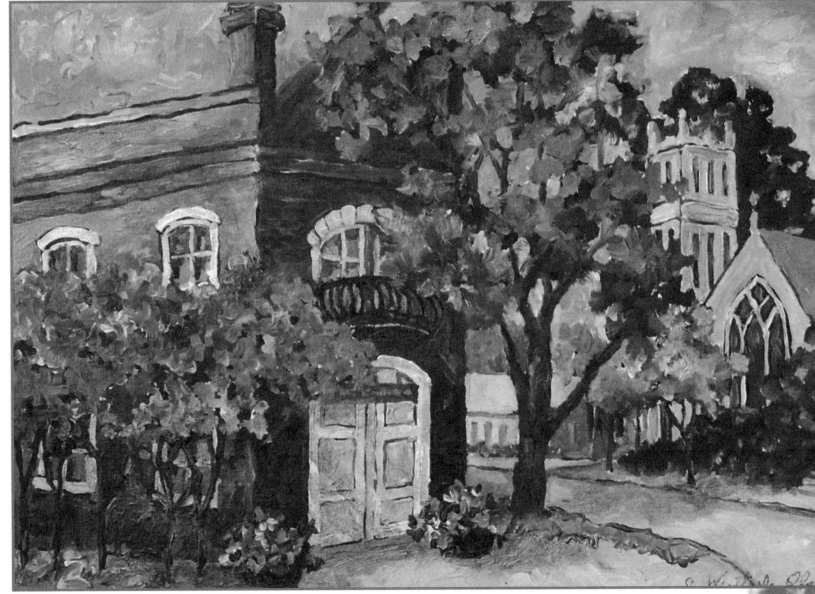

Charlene Winterle Olson

Fire Hall #2 built in 1901 on Prince Avenue is now the headquarters of Athens-Clarke Historic Foundation.

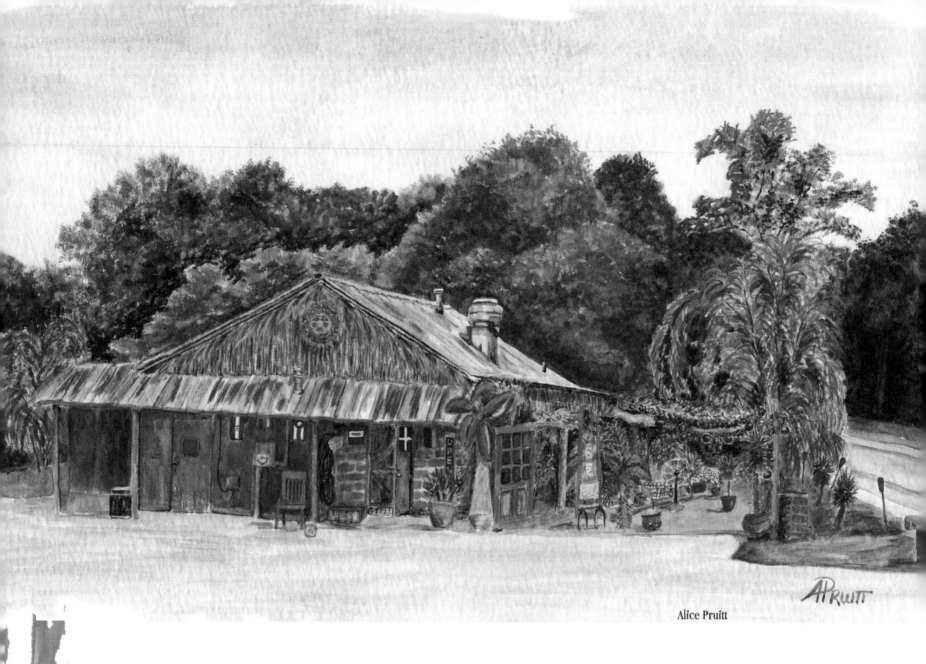

Alice Pruitt

Caliente Cab, one of the first Latino restaurants, was known for its good food and unique atmosphere. Those who remember its humble beginnings still refer to it as "The Trailer."

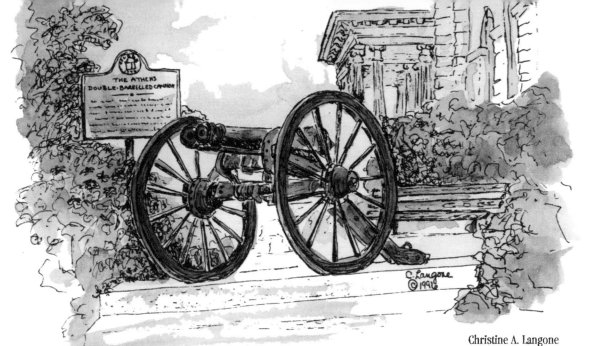

The Athens Double Barreled Cannon is the only known cannon of its kind. It was designed during the Civil War and cast in an Athens foundry. The two barrels were meant to fire two balls connected by a chain in order to "mow down the enemy." The cannon is located in downtown Athens at the corner of Hancock Street and College Avenue at City Hall.

Christine A. Langone

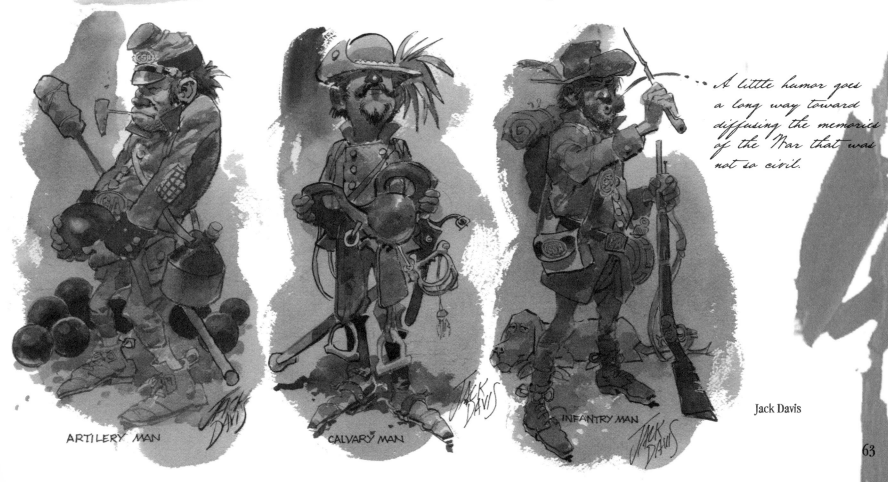

ARTILERY MAN

CALVARY MAN

INFANTRY MAN

A little humor goes a long way toward diffusing the memories of the War that was not so civil.

Jack Davis

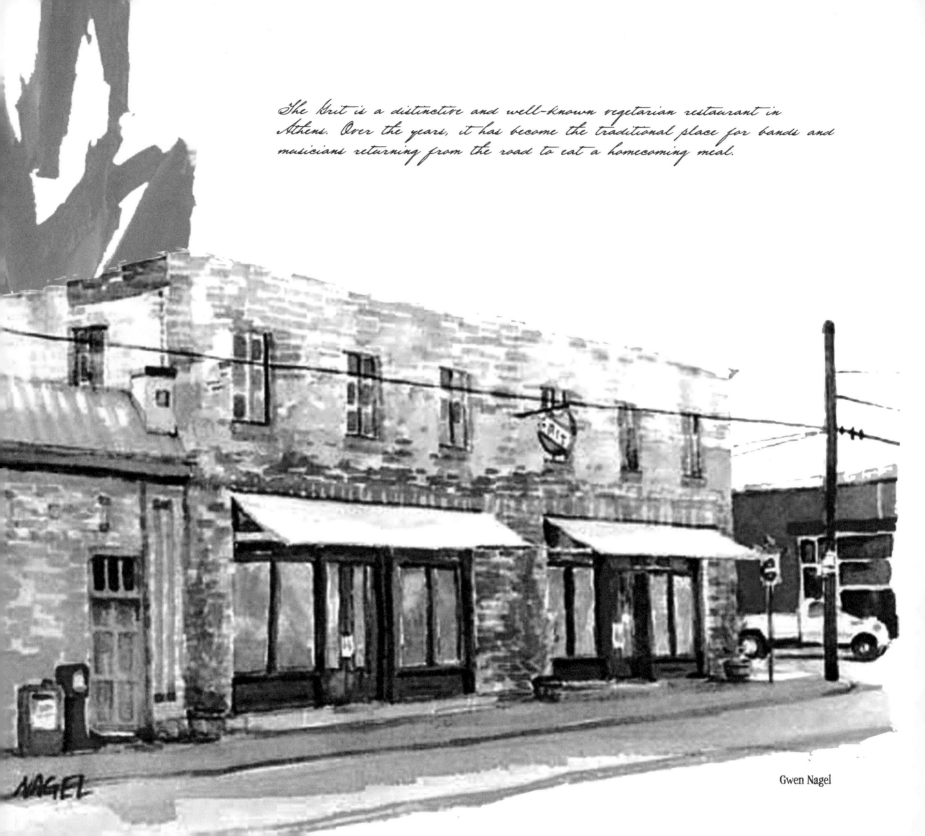

The Grit is a distinctive and well-known vegetarian restaurant in Athens. Over the years, it has become the traditional place for bands and musicians returning from the road to eat a homecoming meal.

Gwen Nagel

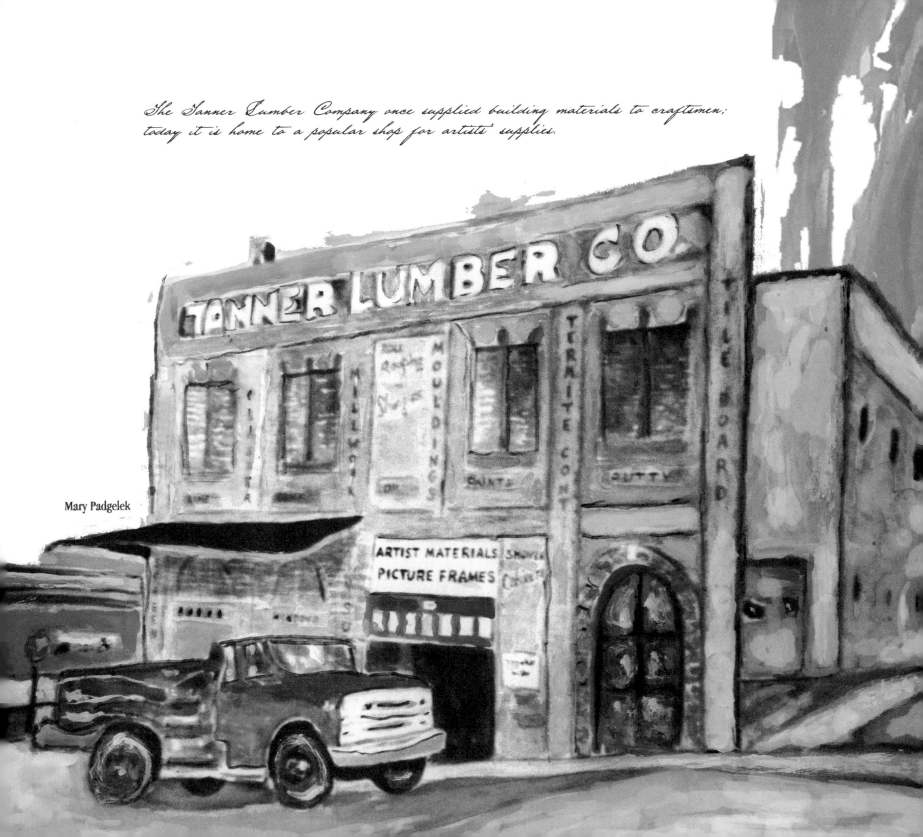

The Tanner Lumber Company once supplied building materials to craftsmen; today it is home to a popular shop for artists' supplies.

Mary Padgelek

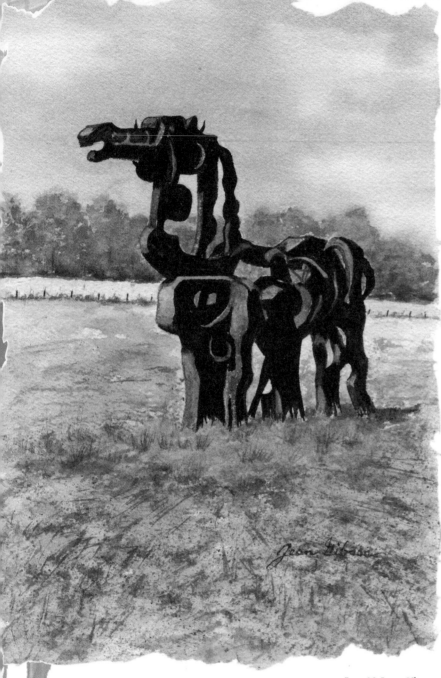

Jean McLean Gibson

The Iron Horse was placed on the UGA campus and the students rejected it. It was moved to a Greene County farm in view of Hwy. 15 south of Athens.

Watson Mill Bridge is the longest covered bridge remaining in Georgia. It is over 100 years old, held together by wooden pins, and spans 236 feet across the Broad River. It is part of the Watson Mill State Park, located 22 miles from Athens, near Comer, Georgia.

Nancy C. Roberson

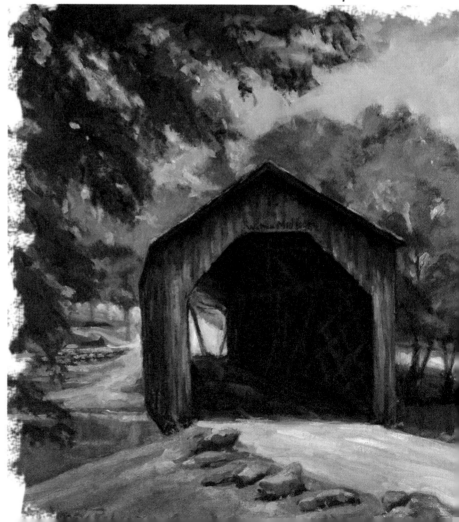

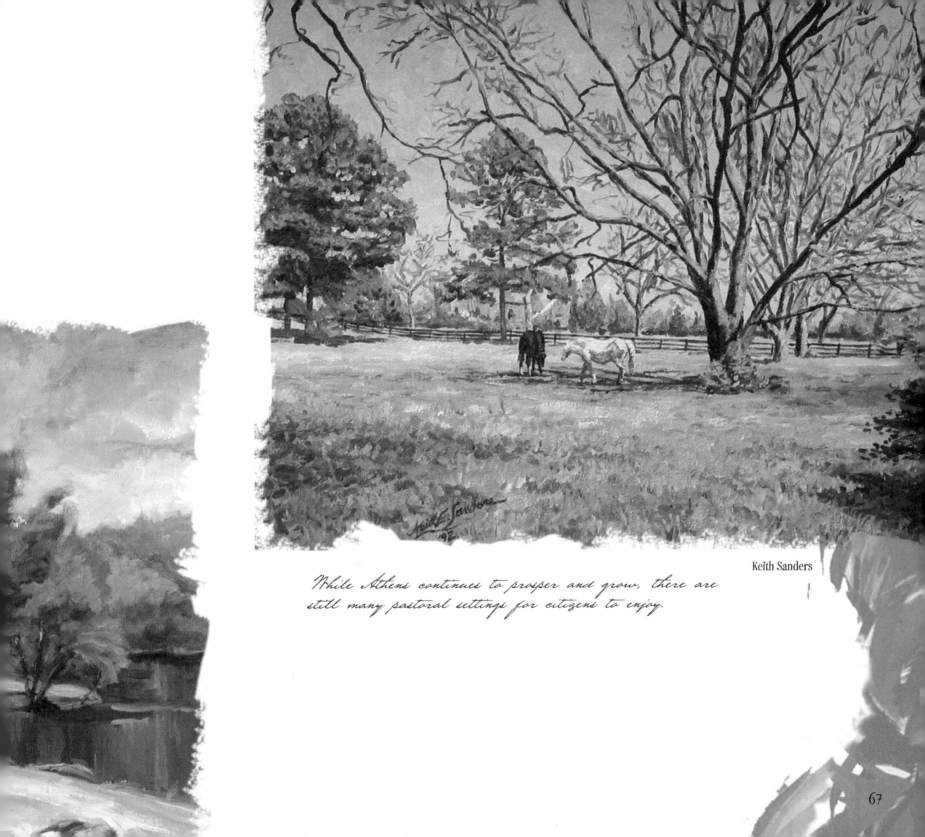

Keith Sanders

While Athens continues to prosper and grow, there are still many pastoral settings for citizens to enjoy.

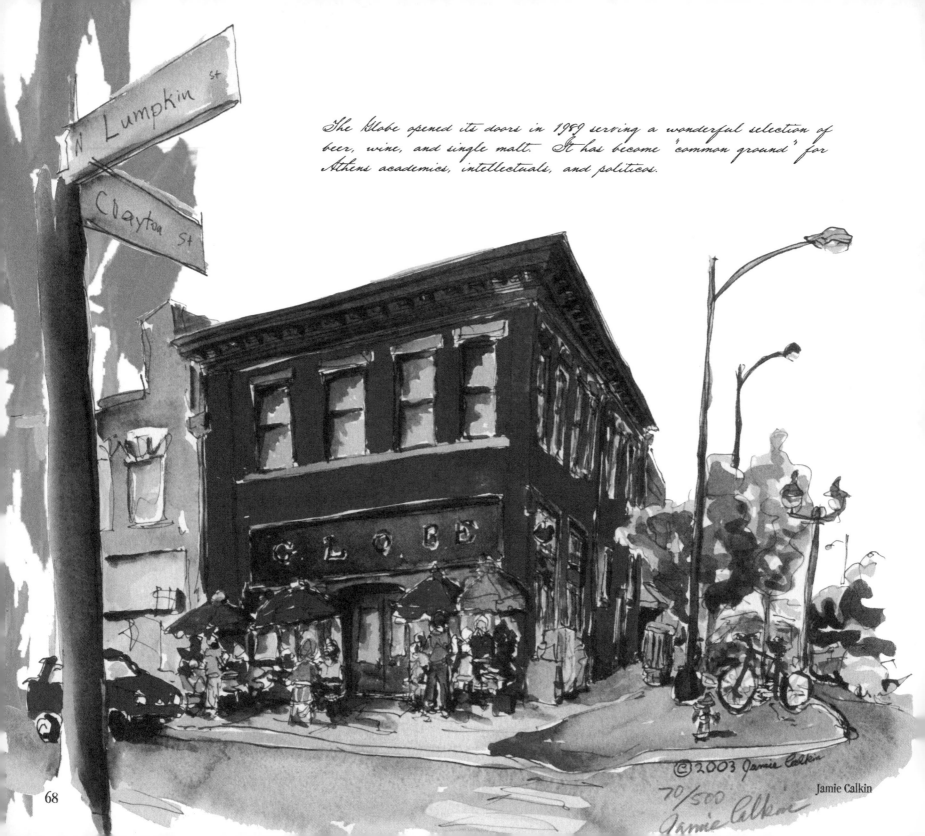

The Globe opened its doors in 1989 serving a wonderful selection of beer, wine, and single malt. It has become "common ground" for Athens academics, intellectuals, and politicos.

N Lumpkin St

Clayton St

GLOBE

©2003 Jamie Calkin
70/500
Jamie Calkin

Jamie Calkin

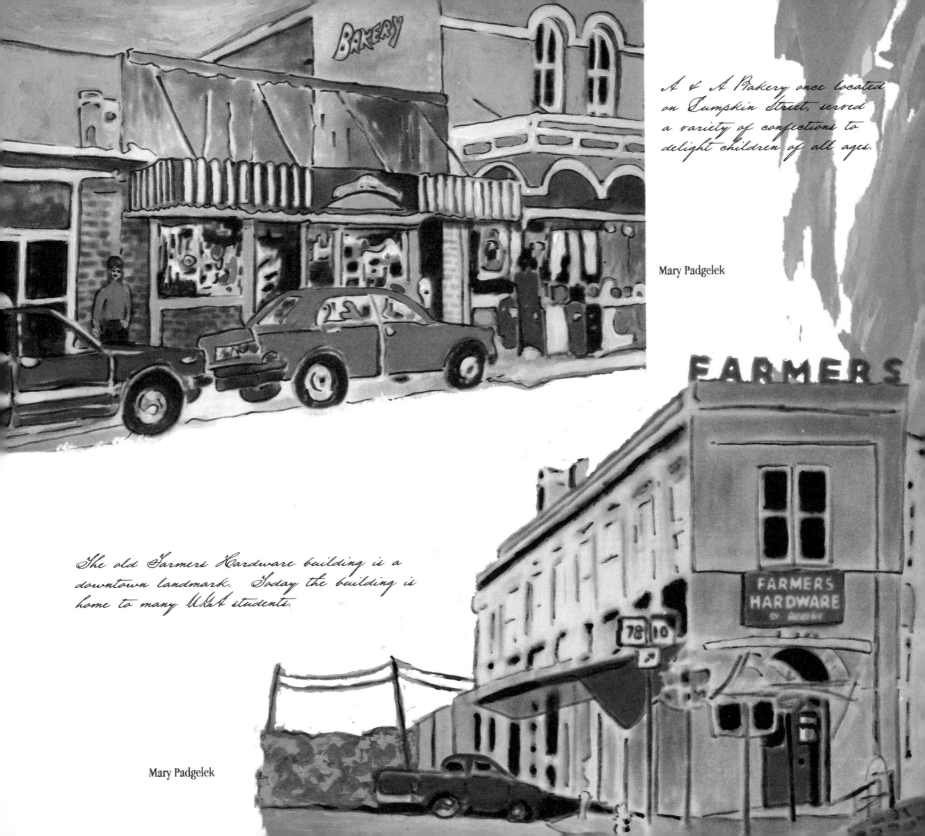

A & A Bakery once located on Tumpkin Street, served a variety of confections to delight children of all ages.

Mary Padgelek

The old Farmers Hardware building is a downtown landmark. Today the building is home to many UGA students.

Mary Padgelek

William Vickers Chittick

This charming painting was done by the late William (Will) Vickers Chittick when he was seven years old and attending Saturday morning art classes at the Lamar Dodd School of Art at the University.

Tasty World bar has been the scene of many an eclectic evening, ranging from trapeze artists to Sunday night worship services—not your average bar.

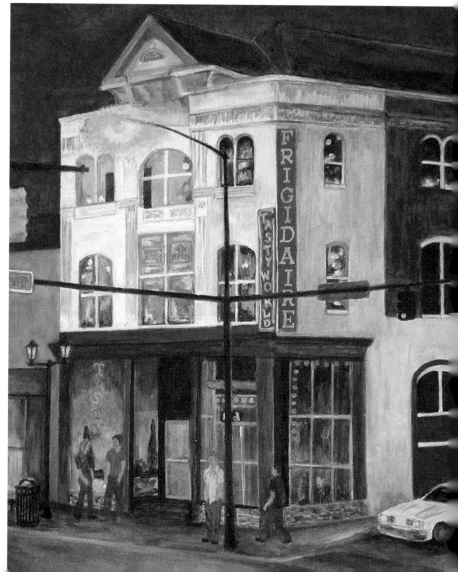

Angela Moore

Sean Jones, the hard hitting tackler with excellent leaping ability, intercepting a pass when he played for U.G.A. Sean now plays for the NFL Cleveland Browns.

John Gholson

This ante-bellum house on Milledge Ave. is the current home of Gamma Phi Beta Sorority.

Keith Karnok

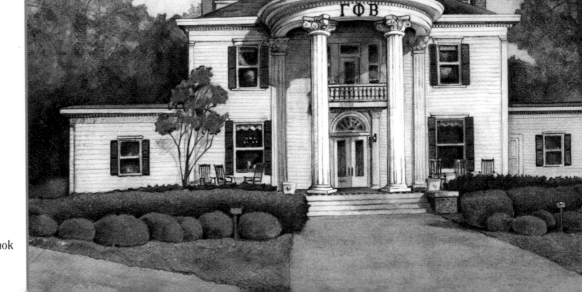

Legendary supporter of the community and the arts, Clementi Holder once celebrated her birthday with a party inside the Classic Center Theatre.

Brent Chitwood

Prince Avenue at Pope Street. The first building on the left is angled to fit the unusual lot. Formerly a refrigeration business, it now houses the Co-op organic grocery store, affectionately known as The Daily. Private homes are bracketed by the Daily on the left and House of 10,000 Frames on the right.

Carol Downs

The Dean Day Lewis Chapel, located at the State Botanical Garden of Georgia, is a popular venue for weddings, parties, and retreats.

Jean McLean Gibson

Built 1896 on the corner of Paris St. and W. Broad St. was one of the first public African American schools in Athens. With six classrooms and library, and no indoor plumbing, it was heated with a potbellied stove. In 1939 a new school was built a few feet east and the original structure demolished.

Paul Davidson

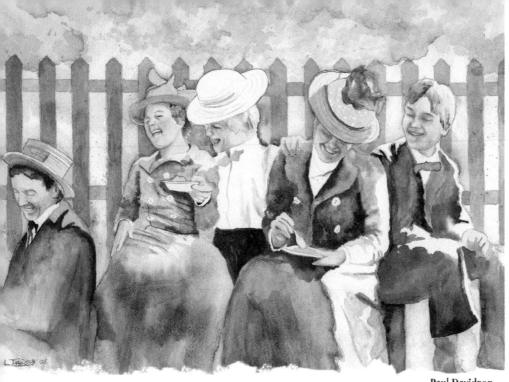

Paul Davidson

During the 1890s ice cream socials were very popular. This painting is from a photograph taken of Helen and Olivia Carlton, twin daughters of Henry Hull Carlton, Athens physician, U.S. Congressman, and owner of the _Athens Banner_ newspaper.

The Southern Cotton Oilseed Company.

Stan Mullins

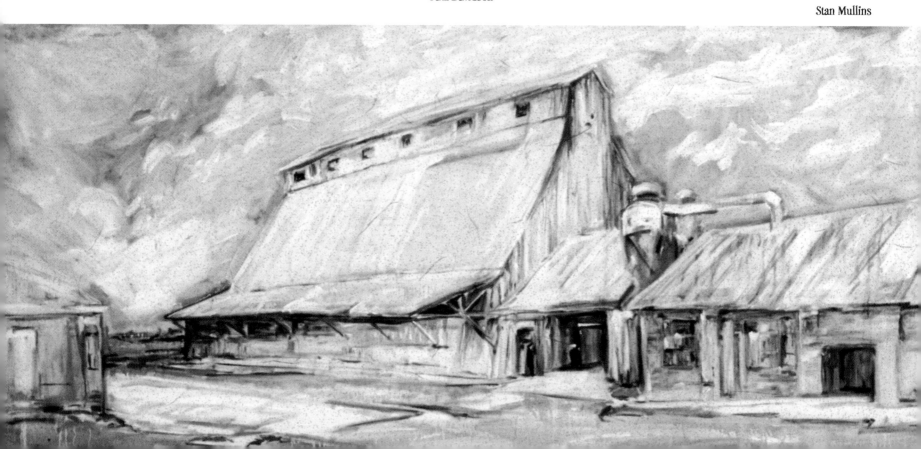

The Athens-Clarke County City Hall occupies the highest point in the central business district of town and is easily recognized by its domed cupola, which houses a clock. It was designed by Augusta architect, L. F. Goodrich and was completed in 1904.

Nancy C. Roberson

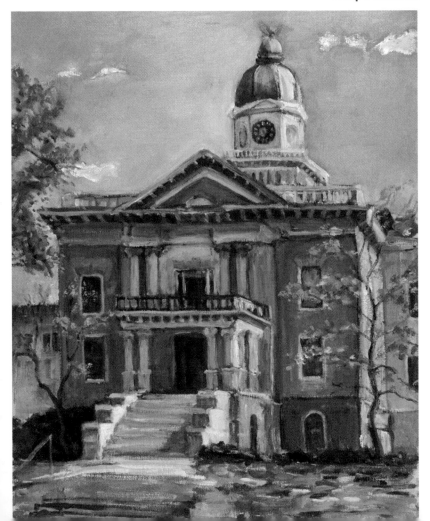

Kathryne D. Whitehead

"We Let the Dogs Out" is a public art project coordinated by the Athens Oconee Junior Women's Club to raise funds for a variety of local non-profits. Thirty-six fiberglass bulldogs have been interpreted by local artists and placed in a variety of locations around town. This painting depicts an artist working on the bulldog for the Athens Ben Epps Airport.

75

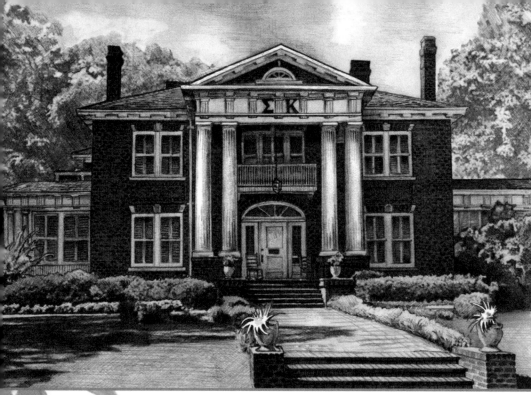

The University of Georgia has a very prominent Greek life. This is a graphite drawing of one of the many fraternity and sorority houses that line the famous Milledge Avenue in Athens. This house is the current home of the Sigma Kappa sorority.

Keith Karnok

The first apartment building in Athens, the Henrietta Apartments (Five Points), is still a popular choice.

Mary Padgelek

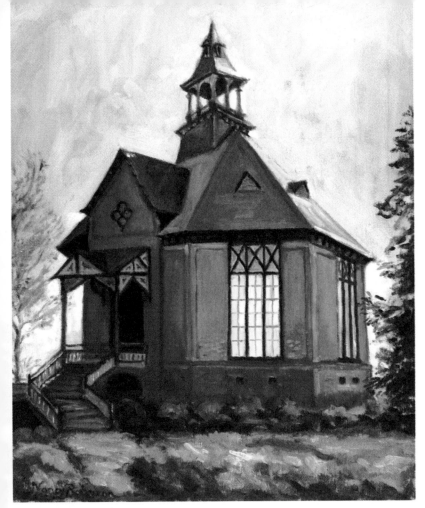

Nancy C. Roberson

Seney-Stovall Chapel – The Chapel, which sits on Milledge Avenue, was built in 1885 as part of the Lucy Cobb Institute. The University of Georgia purchased the Institute in 1931, and the Chapel was used as a theater. It fell into disrepair and was boarded up. Money was raised, and in 1997 restoration was completed.

The Morton Theatre was the first black owned and operated vaudeville theater in the nation. Built in 1910 and restored on the 1990s, the theater is listed on the National Register of Historic Places.

W. Joseph Stell

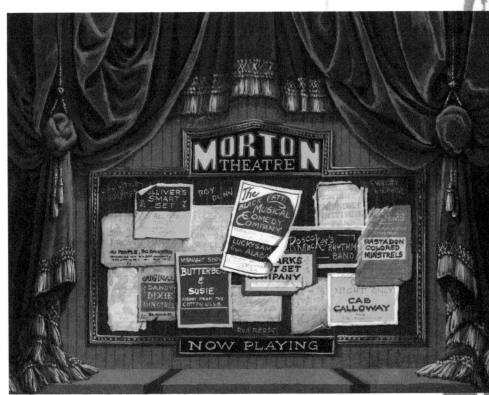

These old buildings on N. Jackson Street appear to be coming to life under the brush of artist John Gholson.

John Gholson

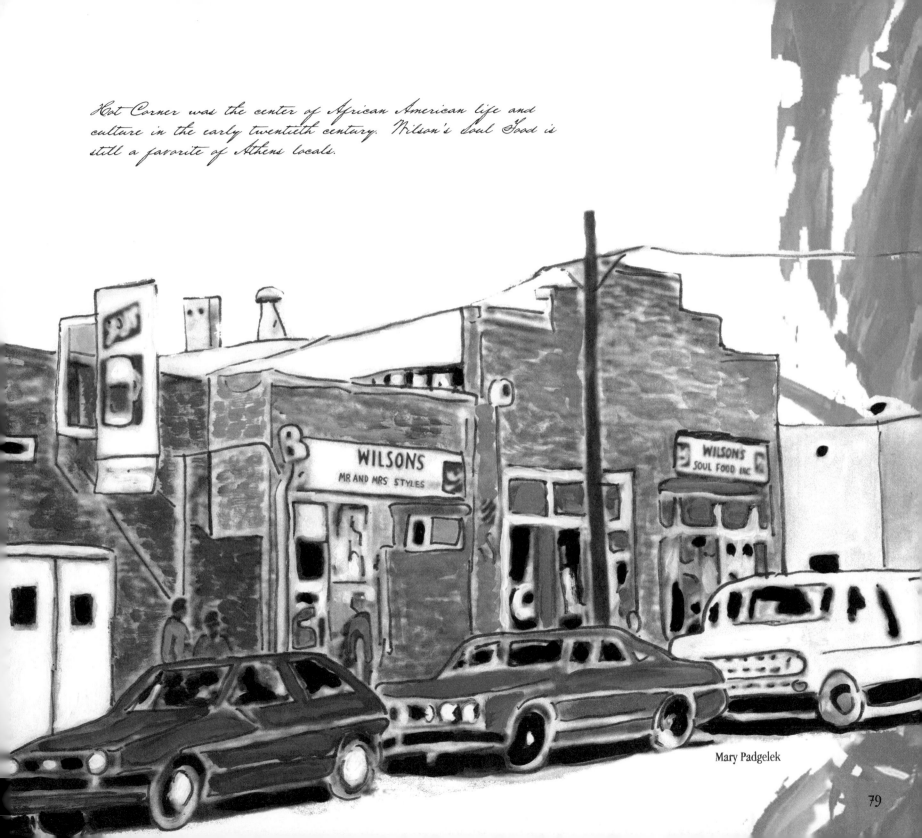

Hot Corner was the center of African American life and culture in the early twentieth century. Wilson's Soul Food is still a favorite of Athens locals.

Mary Padgelek

Built in 1909-1910 in what was then a thriving black business district, the Morton Theatre is today a community performing arts center.

Chris Wyrick

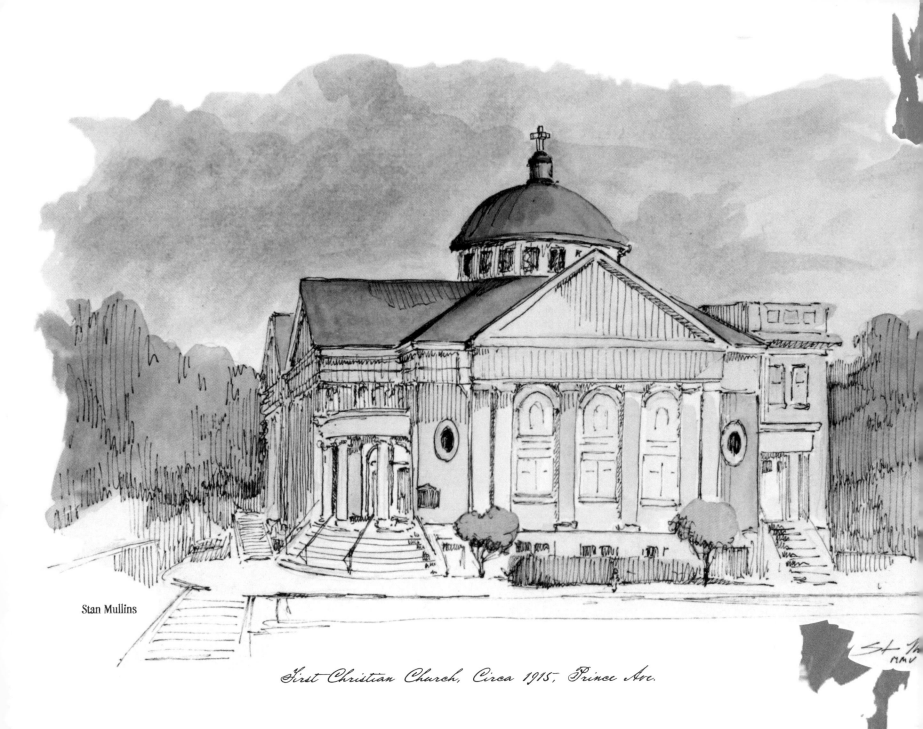

Stan Mullins

First Christian Church, Circa 1915, Prince Ave.

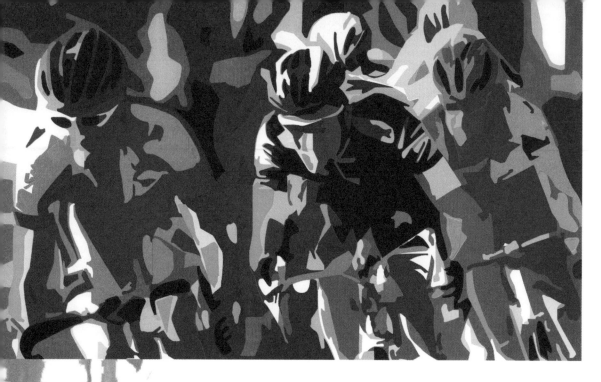

The Athens Twilight Criterion, the most successful downtown festival, recently celebrated its twenty-fifth anniversary.

T.K. Harty's Saloon in the old railroad depot was for years shrouded in a notorious local mystery. The building is now home to the Athens Council on Aging.

Mary Padgelek

The Blue Sky Coffeehouse, as interpreted in an unusual batik rendering, is a scene familiar to Athenians.

Rene D. Shoemaker

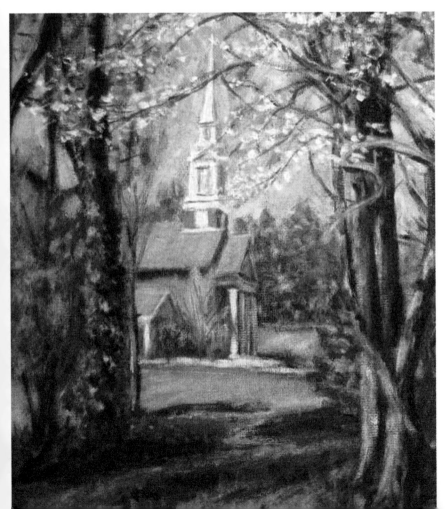

Central Presbyterian Church, located on Alps Rd.

Keith Sanders

83

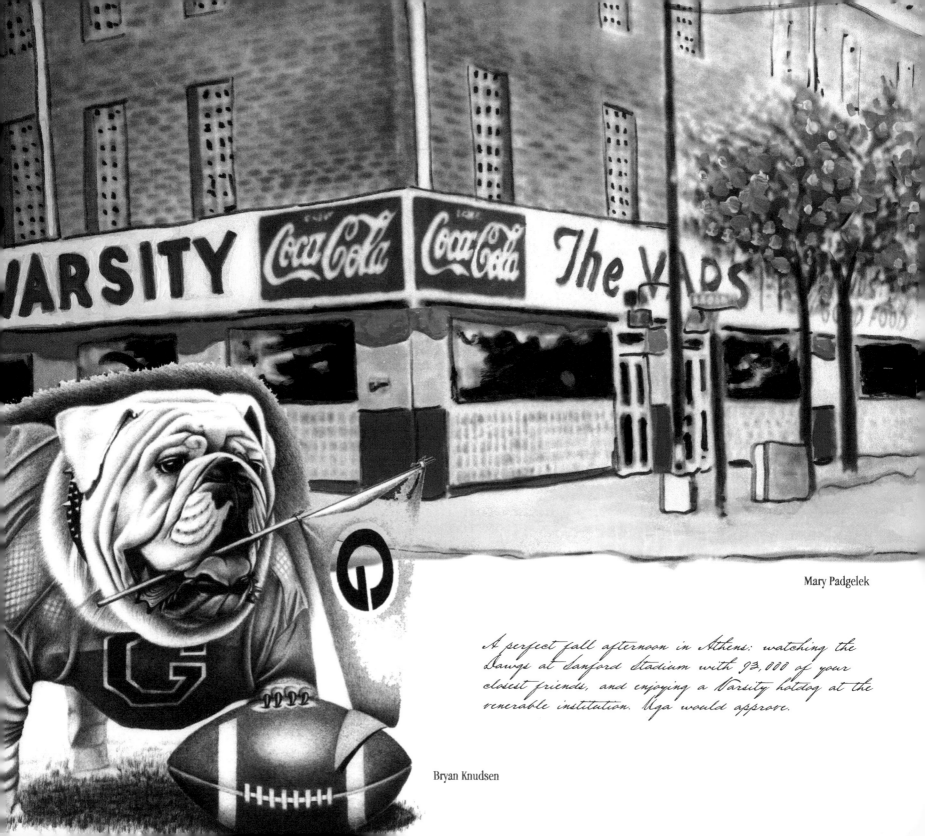

Mary Padgelek

A perfect fall afternoon in Athens: watching the
Dawgs at Sanford Stadium with 93,000 of your
closest friends, and enjoying a Varsity hotdog at the
venerable institution. Uga would approve.

Bryan Knudsen

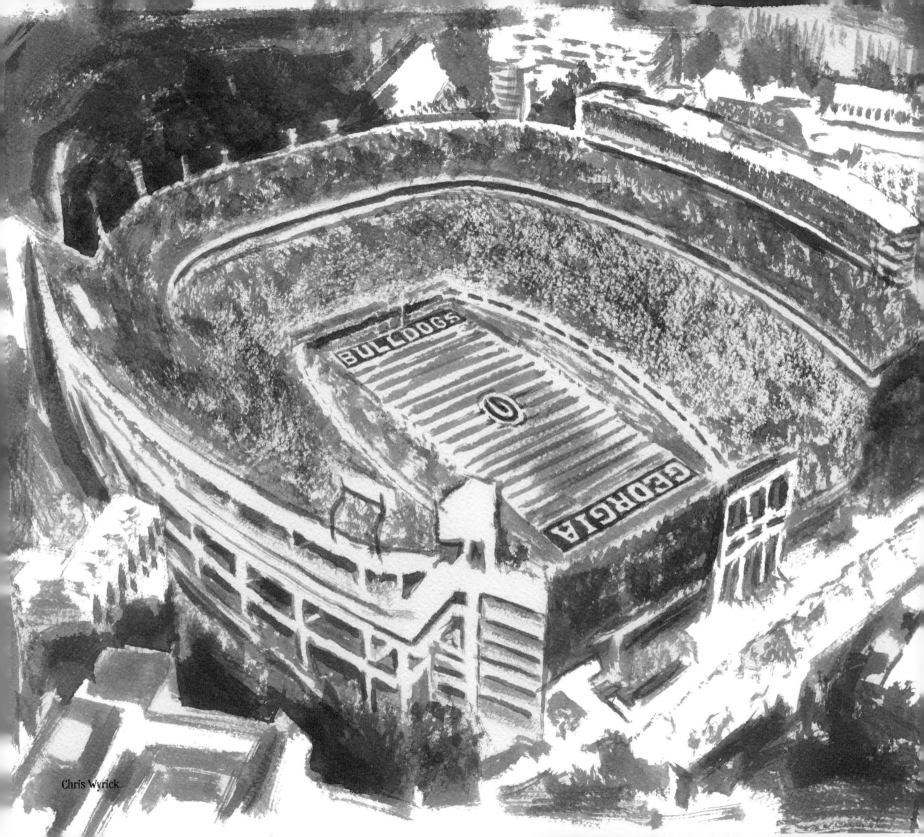

Chris Wyrick

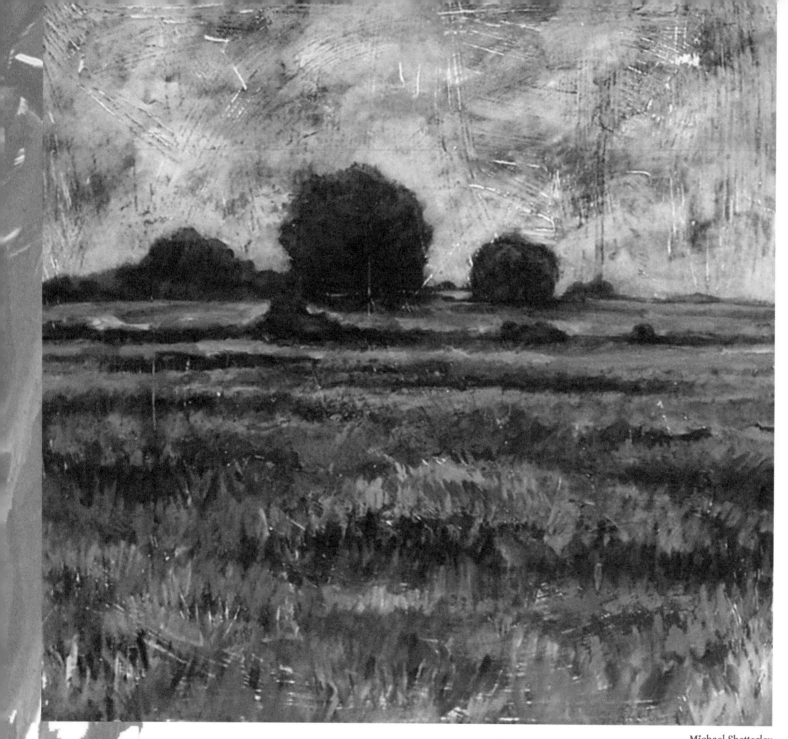

Michael Shetterley

While Athens continues to grow in every direction, there are still lovely rural areas like this one, found on Highway 441 to Commerce.

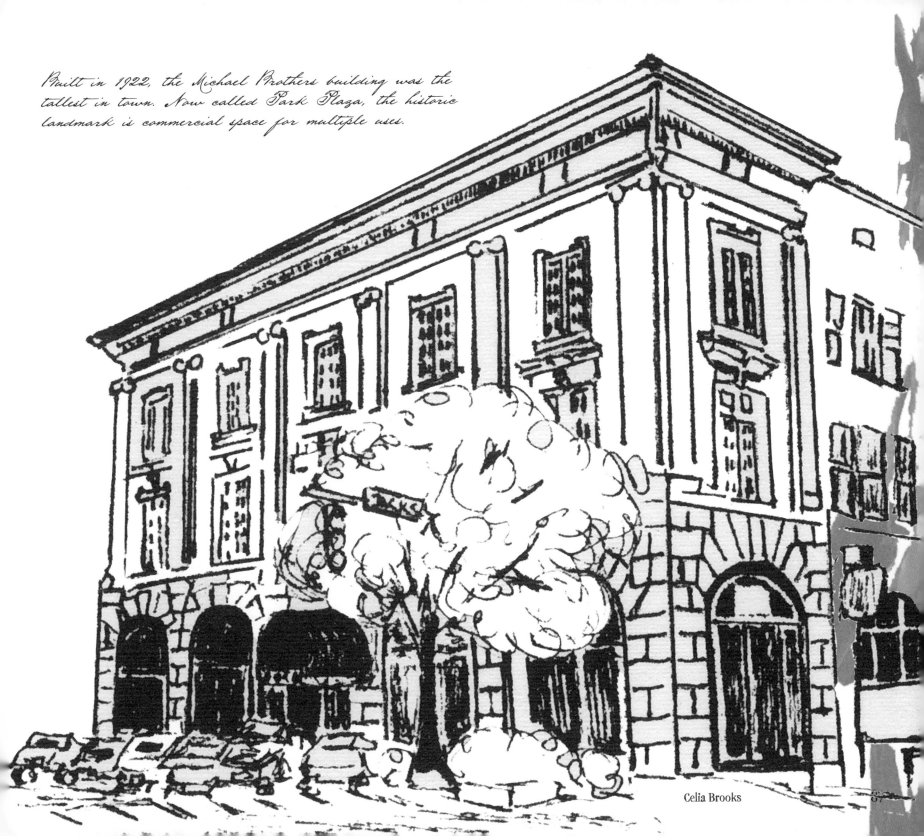

Built in 1922, the Michael Brothers building was the tallest in town. Now called Park Plaza, the historic landmark is commercial space for multiple uses.

Celia Brooks

Gwen Nagel

Herb Garden, Church-Waddel-Brumby House. 280 East Dougherty Street. The Federal period house, built in 1820, is the oldest surviving residence in Athens. Restored by the Athens-Clarke Heritage Foundation, the house now serves as a museum and the Athens Welcome Center. A local garden club, the Piedmont Gardeners, tends the herb garden at the house and also sponsors the annual Garden tour of Athens every spring.

A fountain in the Heritage Garden area at the State Botanical Garden of Georgia.

Jo Adang

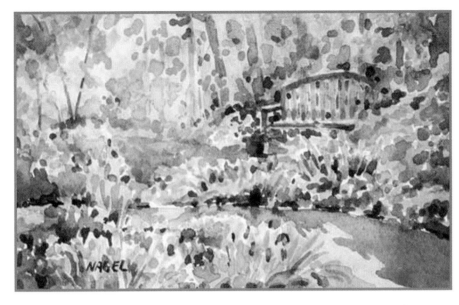

Gwen Nagel

An Athens garden in Spring. Athens' neighborhoods boast numerous lovely gardens, both large and small. An annual garden tour, sponsored by the Piedmont Gardeners, highlights some of the loveliest and most impressive spring gardens in Athens.

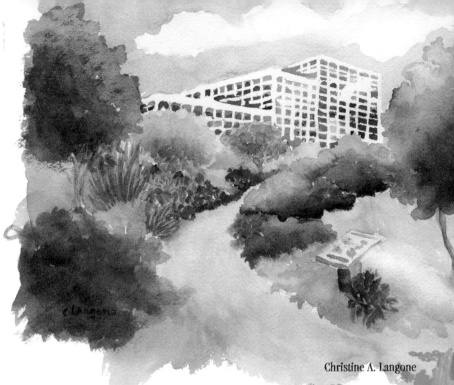

Christine A. Langone

Visitor's Center at the State Botanical Garden on S. Milledge Avenue. Completed in 1984, it contains a three-story conservatory featuring tropical plants.

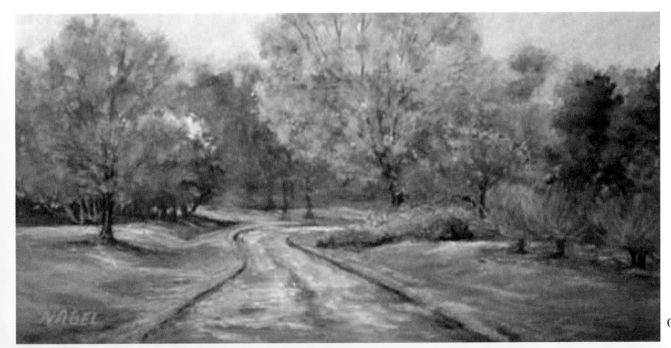

Entrance to the State Botanical Garden of Georgia. 2450 South Milledge. Covering 313 acres, the State Botanical Garden of Georgia features woodland walking trails, a tropical conservatory, the headquarters of the Garden Club of Georgia, and a variety of gardens showcasing plants from around the world.

Gwen Nagel

89

The old oak tree by the University Arch has through the years gently eased aside the wrought iron fence and steadily grown.

Stan Mullins

Athens House in 5-Points, Spring.
Athens boasts a rich architectural
heritage, with numerous unique
residential and shopping neighborhoods.
The 5-Points area is but one that is
particularly charming in the spring.

Gwen Nagel

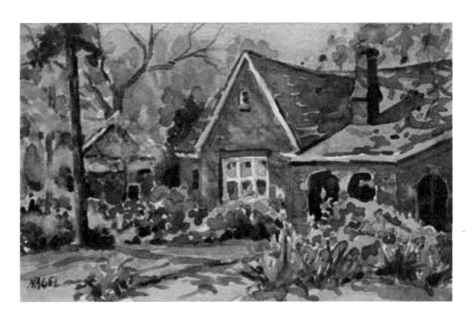

This unusual interpretation
of several familiar downtown
sights—some now gone—
includes from left to right:
Bluebird Cafe on Morton
Avenue, the Varsity on West
Broad Street, the Coliseum
on Carlton Street, the C &
S Bank on North Lumpkin
Street, The Grill on East
Broad Street, the Clarke
County Courthouse on College
Avenue, and "The Tree That
Owns Itself" on Dearing
Street.

William Vickers Chittick

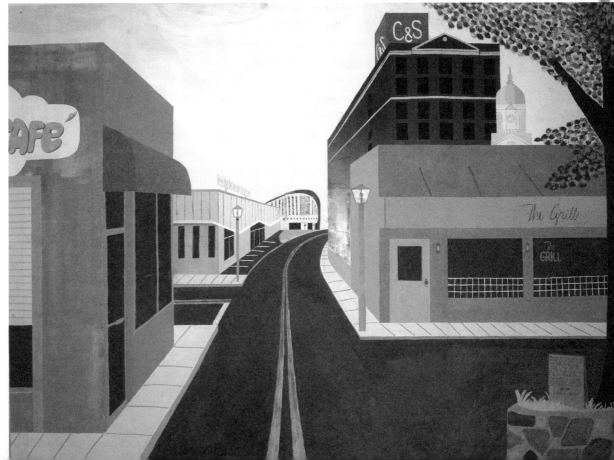

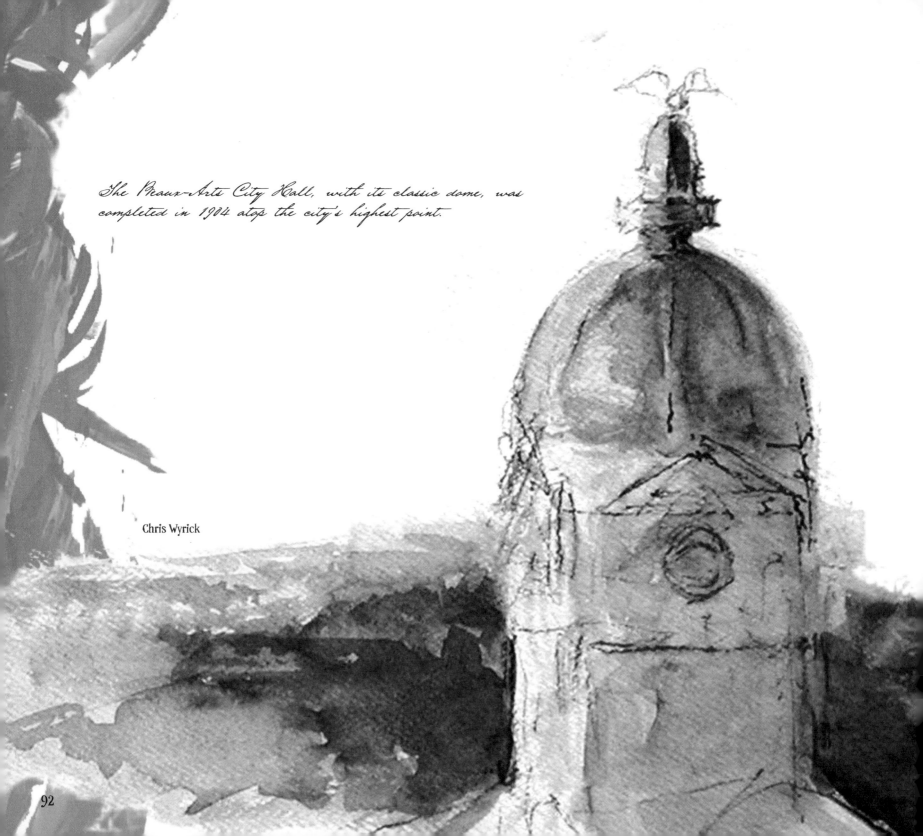

The Beaux-Arts City Hall, with its classic dome, was
completed in 1904 atop the city's highest point.

Chris Wyrick

Athens Sketchbook
Benefactors

Noramco, Inc.

NORAMCO (North American Chemical Company) was formed in Wilmington, Delaware in 1979 by Johnson & Johnson, the world's most comprehensive and broadly based health care company. The Athens, Georgia, site was established in 1981 and is now the worldwide headquarters of the Noramco franchise. NORAMCO is one of over two hundred operating companies in fifty-seven countries around the world owned by Johnson & Johnson.

NORAMCO, Inc. manufactures active pharmaceutical ingredients and fine chemicals for use in Johnson & Johnson Family of Companies' products. In addition, this manufacturing base has expanded to include medical devices and pain management compounds for most of the worlds' major pharmaceutical companies. These health care products, serving the consumer, pharmaceutical, diagnostics, and professional markets, enable people throughout the world to live longer and healthier lives.

When it comes to improving people's lives, no company can match the diversity and multitude of products and services Johnson & Johnson provides across the health care spectrum. Beginning production in March 1886, with fourteen factory workers in New Brunswick, New Jersey, antiseptic surgical dressings were among Johnson & Johnson's first products.

Innovative products followed in 1894 with JOHNSON's® Baby Powder, a talc to soothe skin irritated by medicated plaster. JOHNSON's BAND AID® Brand Adhesive Bandage was introduced in 1920, and beyond the consumer segment followed products within the pharmaceutical field, which later introduced TYLENOL® in 1960. Today, Johnson & Johnson's pharmaceutical sector continues to strive towards finding new lifesaving and life-enhancing drugs which improve the health of our population, while, at the same time, help control health care costs in this country.

Today, Johnson & Johnson's "platforms for growth" include more than 10,000 products within the areas of skin care, vision care, wound care, nutraceuticals, pain management, mental health, women's health, interventional cardiology, and cancer therapy just to name a few. Advances in research and development of new medicines are emphasized, along with acquisition opportunities, while maintaining, of course, a commitment to quality, safety, and cost-effective products.

Guided by the ethical principles of the Johnson & Johnson Credo established sixty years ago, "We affirm responsibility to our customers, employees, and communities where we live and work..." NORAMCO, as part of the more than 111,000 men and women within the Johnson & Johnson Family of Companies, shares in this responsibility and in the satisfaction of fulfilling health care needs of people throughout the world.

Leadership roles in the community take place annually with the United Way and March of Dimes campaigns as well as the American Red Cross Blood Drive, held four times a year. Personal employee involvement includes Habitat for Humanity, civic activities, and promoting excellence in education through active support of Partners in Education and the Athens Technical College.

NORAMCO is proud of the contributions it makes toward improving the quality of life-today, tomorrow, and well into the future. This in-house supplier of active pharmaceutical ingredients (APIs) and raw materials that are the building blocks for many of Johnson & Johnson's products, is not 'just a chemical company.' Sporting the tag line "Actively in Your Life," NORAMCO is an active and visible company--determined to become number one in the lives of its J&J affiliates and worldwide customers.

The multi-faceted initiative known as Process Excellence has helped NORAMCO achieve business results, create customer and employee satisfaction, and sets the stage for future success. Thanks to this comprehensive program, NORAMCO's vision—to be the preferred supplier of APIs to Johnson & Johnson affiliates and the world leader in controlled substance APIs and raw materials—is on the horizon. And a bright horizon it is for this ambitious young company that has proven itself worthy of doing business within the most trusted company in America—Johnson & Johnson.

Chemistry • Compliance • Commitment

1440 Olympic Drive
Athens, GA 30601
706-353-4400

Actively in your life...

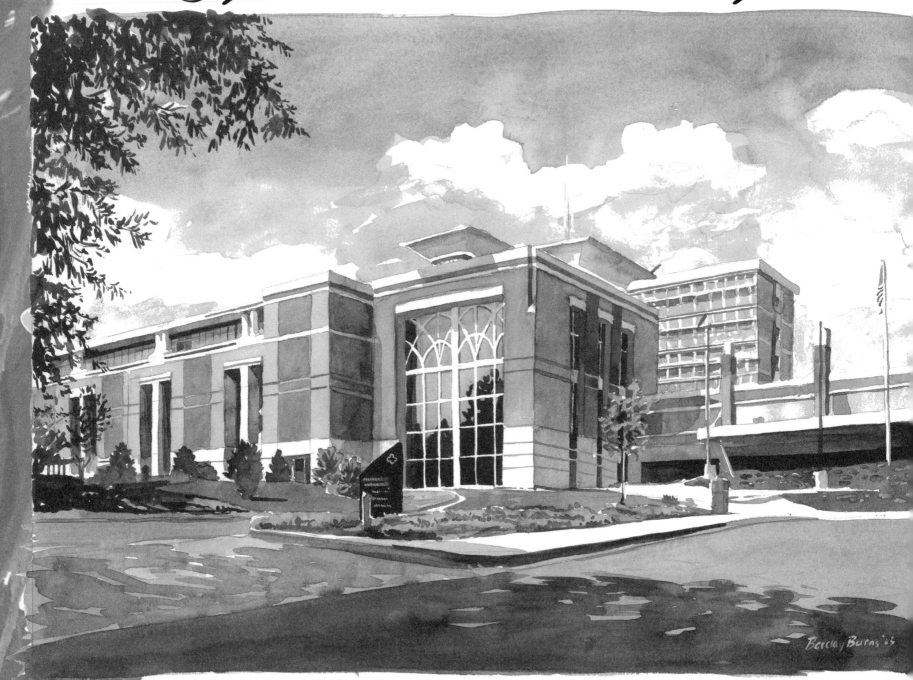

St. Mary's Health Care System

St. Mary's Health Care System in Athens, Georgia, is unique in many ways. To discover what makes St. Mary's such a special place, one has only to read their mission statement:

"As a member of Catholic Health East and sponsored by the Sisters of Mercy, the mission of St. Mary's Health Care System is to be a compassionate, healing presence in our community, committed to the sacredness of human life and the dignity of each person we serve."

This mission is founded on St. Mary's core values, including Excellence, Reverence for Each Person, Community, Stewardship, and Integrity. "We will respect the needs and value the dignity of every individual and continually seek to improve the lives of all we serve," St. Mary's states in its Vision Statement. "We will be progressive and responsive to change across the healthcare continuum and will be considered a vital part of the community."

As a result of that vision, every day St. Mary's addresses the healthcare needs of people of all ages from across Northeast Georgia by providing:

• An acute care hospital with special emphasis on general medicine, general surgery, neurosciences, orthopedics, women's and children's health, cardiac care, gastroenterology, and services for seniors.

• A 24-hour emergency center and ambulance service.

• The region's largest home healthcare/hospice services agency.

• Athens' only inpatient acute rehabilitation unit, the Center for Rehabilitative Medicine.

• An industrial medicine practice to help employers and employees prevent and manage workplace injuries.

• Highland Hills, a retirement village that includes independent living, a personal care home, beautiful grounds, dining facilities, and more.

• A Wellness Center, Women's Resource Center, Sleep Disorders Center and more to promote good health in convenient, low-stress, environments.

In April 2005, St. Mary's Health Care System dedicated a $40 million renovation and expansion project, dramatically expanding its services to the area. Speaking at the occasion, St. Mary's President and CEO Tom Fitz, said, "The new St. Mary's will bring a whole new level of care, compassion, and technology to Athens and Northeast Georgia. This project directly addresses some of our region's most pressing healthcare needs, from more effective cancer diagnosis to saving the lives of premature babies."

The center features a new well-baby nursery and dedicated C-section surgical suites, and has expanded its neonatal intensive care unit to care for up to 22 infants at a time. The expansion also brings new super-fast, more comfortable MRI services into the hospital building, creates new suites for its high-tech CT scanners, and locates them near the Emergency Center for urgent diagnostic studies in life-threatening situations.

The new St. Mary's also includes a Breast Imaging Center, offering the best in digital mammography facilities; a Women's Diagnostic Suite, with the latest in technology, including the region's only MRI-guided breast biopsy system, super-fast CT scanning, ultrasound and stereotactic biopsy; and a Family Birthing Center, the first in the region to feature labor-delivery-postpartum-recovery suites, allowing moms to labor, deliver, recover, and care for their newborn in one room, and allowing dad to stay overnight.

St. Mary's also is taking the lead in addressing two of the major causes of death and disability in Northeast Georgia: Stroke and heart attack. St. Mary's Stroke Center was recently awarded the Gold Seal of Approval and Disease-Specific Care Certification for stroke by the Joint Commission on the Accreditation of Healthcare Organizations. St. Mary's also recently introduced Remote EKG transmission to Northeast Georgia. Emergency medical personnel can now send vital information about a patient's heart function to St. Mary's emergency room and even an on-call cardiologist direct from the scene.

St. Mary's believes in providing high quality health care. Its Family Birth Center staff won the 2005 Advance for Nurse's magazine award for Best Nursing Team for Promoting Staff Education. The system as a whole was honored in 2004 by the Georgia Alliance of Community Hospitals as one of Georgia's large hospitals of the year. Blue Cross/Blue Shield of Georgia recently honored St. Mary's as a Top Performing Hospital for pneumonia care. And St. Mary's offers pastoral care and interpreter services to meet all needs of the patient and family.

Throughout the life span, St. Mary's is there, faithful to its mission, living out the words of its vision, putting its values into practice.

ST. MARY'S
HEALTH CARE SYSTEM
Feel better here.

1230 Baxter St., Athens GA 30606
(706) 389-3000 www.stmarysathens.org

Benson's Incorporated

In 1938, Mr. W. H. Benson opened a wholesale bakery on the corner of Washington and Thomas Streets in downtown Athens. From 1938 until 1988, the aroma of freshly baked Benson's bread permeated every corner of the city. The bakery operation provided bread, rolls, buns, and other baked products for North Georgia until production was moved to Benson's Bakery in nearby Bogart, Georgia. Shortly thereafter, the building was demolished and replaced with a parking lot until 2005 when the state-of-the-art Hilton Garden Inn was built on the very site that the bakery once stood.

Through the years, as the Benson family business was handed down from generation to generation, the operation expanded into the hospitality industry and now Benson's Inc. operates three hotels in addition to its bakery roots.

The Bensons first ventured into hotel operations with the opening of the Athens Holiday Inn in 1958, which still stands on the corner of Broad and Hull Streets across from the University of Georgia in downtown Athens. Featuring the lovely Ginkgo Tree Restaurant & Lounge, the Holiday Inn offers a wide variety of amenities, including an indoor pool, a modern exercise facility, and meeting space to accommodate up to 300 guests. The Holiday Inn has been expanded several times over the past forty-seven years to its current 306 rooms, making it the second largest full service Holiday Inn in Georgia. The family's second hotel came in 1998 with the introduction of Athens Holiday Inn Express, formerly the Ramada Inn, just a few blocks away. All rooms open to an interior corridor and include a free deluxe continental breakfast each morning. The Express also features a modern exercise facility, a business center, and an outdoor pool. Meeting space at the Holiday Inn Express accommodates up to 200 guests.

Downtown Athens' newest landmark rounds out the Benson's ventures

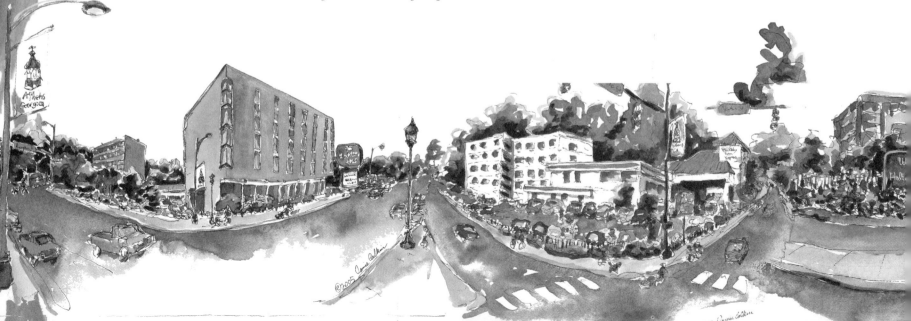

in Athens. The Athens Downtown Hilton Garden Inn, which stands directly across from the Classic Center on the original Benson's Bakery site, is Athens' second largest private investment in the downtown district and the largest single unit, privately owned hotel construction in Clarke County. The facility features an indoor pool and Jacuzzi, state-of-the-art fitness center, executive boardroom, and 2,600 square feet of meeting space. Its three-room presidential suite, two-room suites, and five mini-suites offer luxury and convenience for guests. All rooms are equipped with HDTV, on-demand movies, video games, DVD, and complimentary HBO. A microwave, refrigerator, high-speed Internet access, luxury bedding, and polished granite vanities complete each room. A two-story atrium lobby with piano bar highlights the entryway and leads to a 72-seat breakfast restaurant.

For more than a half century, the Benson family has met the needs for excellent hotel and conference accommodations in the Athens area, as well as producing quality bakery goods. As the city has grown, so has Benson's dedication to continue to meet the needs of a vibrant, progressive community and to be a partner in all the remarkable things that happen in Georgia's Classic City.

Holiday Inn and Holiday Inn Express:
www.HI-Athens.com
706-549-4433
Hilton Garden Inn:
www.HiltonGardenInn.com
706-354-6431

burton + BURTON
(formerly known as Flowers, Inc. Balloons® Burton & Burton®)

burton + BURTON® (formerly known as Flowers, Inc. Balloons® Burton & Burton®) was founded by Maxine H. Burton in 1982. Shortly thereafter, her husband, Robert E. Burton, joined the company on a full time basis as Chief Executive Officer. Together, they have grown burton + BURTON® into the largest supplier of balloons and related gift items in the world. In 2000, they expanded the business to include the burton + BURTON® line of home décor accessories which has become a vital and integral part of their ever-growing product line.

Early in their marriage, Maxine worked with her husband in the wholesale floral business and began researching ways to revolutionize that industry. She discovered that people were fascinated with unusual balloons, especially the newly invented silver foil balloons that she had eyed at a trade show. She began to market the idea that a balloon could be a profitable and innovative add-on to a floral arrangement – a floating greeting card imprinted with inspirational or catchy phrases. She quickly began to receive orders from existing customers and, in 1982, Flowers, Inc. Balloons® (now known as burton + BURTON®) was born.

Although the company began with an innovative idea for foil balloons, Maxine has carefully cultivated that idea into an international business. Maxine began designing, manufacturing, and importing from Asia in 1987 and continues to be involved in every step of this process. The burton + BURTON® annual catalog, seasonal catalogs, and monthly newsletters are widely distributed in over ninety countries around the world. burton + BURTON® has grown from a small operation run by Maxine and her immediate family, to a global business employing over 350 employees. The company currently has over 300,000 square-feet of state of the art warehouse and distribution space and maintains permanent showrooms in Atlanta, Chicago, Dallas, and their home offices in Bogart, Georgia.

burton + BURTON® strives to offer the highest level of customer service in the industry, employing over seventy top sales people who have been singularly groomed to provide the kind of personal, courteous, customer-oriented assistance that the company has become known for all over the world. The company slogan, "First in Sales, Service and Satisfaction" is practiced each and every day at burton + BURTON®.

Training and ongoing education for burton + BURTON® customers is also a priority. Early on in the company's history, Maxine created "Ballooniversity®," offering burton + BURTON® customers from around the globe the opportunity to visit the home offices of the company, mingle with their peers, and learn the latest and most innovative trends/techniques in the balloon industry. A wide array of accomplished and world-renowned balloon artists and instructors are invited to hold classes for the eager students. Maxine also offers her customers a chance to compete in many categories specific to the balloon industry and an opportunity to gain national exposure for their ingenuity, creativity, craft, and individual businesses. Ballooniversity® is a much anticipated annual event and has set the standard in the trade for customer education and appreciation.

The Burtons have always worked to foster a family-oriented approach to the running of the company. Maxine and Bob consistently practice a very real open door policy. Any employee may reach either or both of them to discuss potential problems, personal challenges, and innovative ideas. To make the working lives of young parents less financially worrisome, burton + BURTON® offers a company benefit providing up to seventy-five percent of the funds necessary to provide quality day care for employees' children.

In addition to the attention that they give to burton + BURTON®, Maxine and Bob believe that civic responsibilities should figure prominently in their personal goals. As a result, burton + BURTON® is involved in all major non-profit fundraisers in the area, including the American Cancer Society's Relay for Life, various March of Dimes events, United Way funding, American Red Cross blood drives, and the American Heart Association's Heart Walk.

As burton + BURTON® is a family owned and operated business, many family members have played key roles in the development and success of the company. With the birth of their first grandchild in 2004, Maxine and Bob are positioning the company so that if they choose, future family entrepreneurs can step in and carry on the successful stewardship of burton + BURTON® – a company that has brought prosperity, enthusiasm, and energy to the Athens/Clarke County area and will continue to do so for generations to come.

burton +BURTON

the TOTAL gift experience

325 Cleveland Road
Bogart, Georgia 30622
706-548-1588
www.burtonandburton.com

Georgia Power
Athens, Georgia

In 1927, Georgia Power's first president, Preston Arkwright, Sr., coined a phrase that has guided generations of Georgia Power employees: "A citizen wherever we serve."

Throughout the state, in so many ways, Georgia Power continually demonstrates its unflagging commitment to being a good citizen and neighbor.

According to Northeast Region Vice President Jim Sykes, "Georgia Power is committed to being an active participant in Athens and is involved with significant community issues and concerns, especially those impacting the environment, education, and economic development."

For Georgia Power, good citizenship begins with customer satisfaction, built on highly reliable service and power rates that consistently are below the national average. Customer satisfaction ratings for the company, for the last several years, have ranked in the top percentile when compared with peers.

But that's just the beginning. In Athens, Georgia Power – the largest subsidiary of Southern Company, one of the country's largest power generators – works side-by-side with community leaders on a variety of initiatives to support education, enhance the local economy, and protect the environment.

Company representatives, for example, serve on local boards and take actives roles with the Chamber of Commerce to support the educational system and economic development.

To ensure safer air quality in Athens and throughout the state, Georgia Power currently is investing more than $1 billion in environmental controls, lowering sulfur dioxide emissions by 39 percent, and nitrogen oxide emissions by 56 percent. Georgia Power also supports an array of other environmental projects to preserve and protect precious natural resources. Besides voluntarily planting thousands of trees and promoting carpooling with its workers, Georgia Power also commits funds and volunteers to The Nature Conservancy for habitat restoration.

To foster a stronger local economy, Georgia Power continually is looking for ways to invest resources that will bring economic gains to Athens. Each year the company plays a key role in channeling numerous capital investment projects and new jobs into Georgia.

Whether delivering world-class service or being effective environmental stewards, people make the difference. Through a steadfast commitment to customer satisfaction and widespread community involvement, Georgia Power's people are a vital part of what makes Athens such a unique and vibrant place to live and work.

GEORGIA POWER

A SOUTHERN COMPANY

Georgia Power is located at 1001 Prince Avenue in Athens, Georgia. For more information, call 800-660-5890, or visit the company's Web site at www.georgiapower.com.

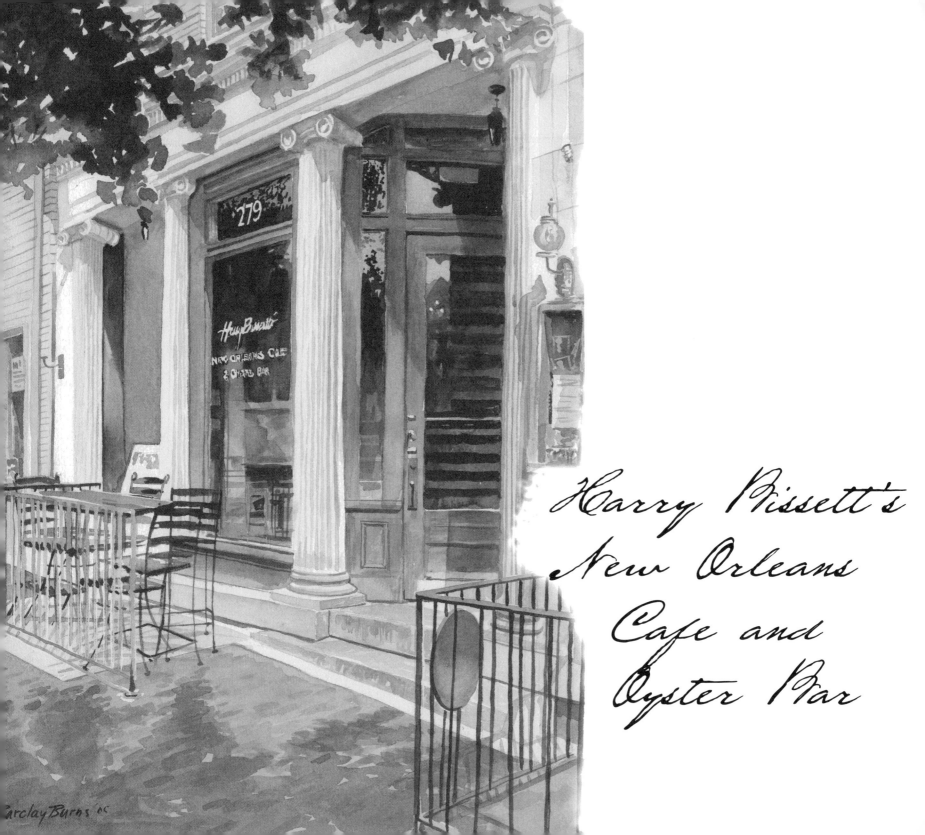

279

Harry Bissett's
New Orleans
Cafe and
Oyster Bar

When George Davis saw the plant-filled, skylight enclosed courtyard dining area of Banker's Restaurant at 279 E. Broad Street, it immediately reminded him of the wonderful old restaurants of New Orleans, one of his favorite places in the world. In 1985, he purchased that business, and, with the help of Jim White (now his business partner) and Neil Smith, a Louisiana native, transformed it into Harry Bissett's New Orleans Café and Oyster Bar. Soon after, local restaurateur Arva Weinstein joined the management team that launched what has proved to be Athens' longest running and most consistently praised fine dining establishment.

Located across the street from the University of Georgia's historic North Campus, Harry Bissett's is housed in the circa 1895 National Bank of Georgia building. Upon entering, one first encounters the cozy bar with its impressive thirteen-foot tin ceiling and turn- of-the-century chandeliers. Depending on the time of day and the season, Harry Bissett's full service bar can be the most pleasant spot in town for a quick bite or full meal, afternoon cocktail, or a lively evening shared with Mardi Gras revelers and college students. There are three distinct dining areas of the restaurant: the downstairs "courtyard," the intimate balcony, and the second floor dining room which features another gorgeous tin ceiling and some of the most requested window tables in town. Throughout, the New Orleans art and jazz in the background hint at the culinary delights about to be experienced.

Since 1986, Harry Bissett's has offered a variety of traditional Cajun/ Creole fare along with original dishes inspired by the rich culinary traditions of Louisiana. Dishes such as Oysters Rockefeller and Bienville, Seafood Gumbo, Shrimp Creole, Filet Mignon Au Poivre, Trout Almondine, and Blackened Fish are prepared only from fresh ingredients daily. To the great credit of Chef Reggie DiSante and his accomplished staff, an extraordinary number of nightly specials have become popular mainstays, including Blackened Lobster Tails, Duck Gueydan, Cedar Plank Salmon, Uptown Stuffed Filet Mignon, and Chef DiSante's Sherry Crab Bisque. Efforts to continually enhance and refine the menu have helped Harry Bissett's to steadily flourish in the years since first opening.

Harry Bissett's New Orleans Café and Oyster Bar serves a full dinner menu nightly; a lunch menu is offered Tuesday through Friday. The New Orleans inspired brunch served on Saturday and Sunday is not to be missed. We look forward to serving you!

Harry Bissetts
New Orleans Cafe

279 E Broad Street
Downtown Athens
706-353-7065
www.harrybissetts.net

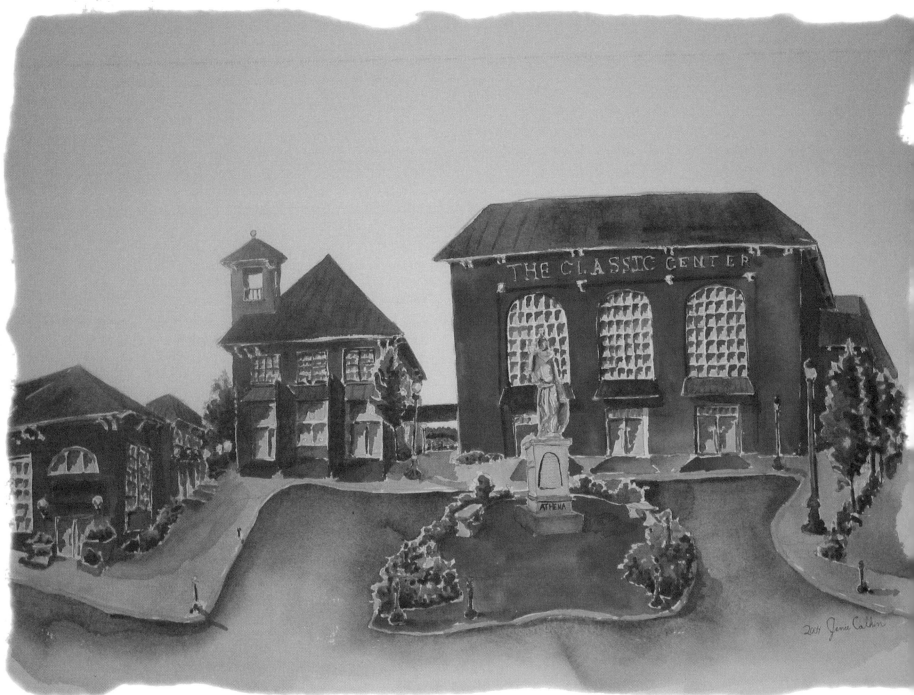

When the Civic Center Study committee formed in 1987 to consider what type facility would best serve the community needs for a public assembly facility, few could have imagined the grand Classic Center that today stands on North Thomas Street in Athens.

The Committee spent countless hours traveling all over the country, meeting with local performing arts organizations, community groups, hoteliers, local businesses, meeting planners, and consultants. At every step of the way, they learned something. That broad body of collected knowledge was brought back to Athens, and the Committee recommended a facility that features the components that have become a part of The Classic Center. Central to the Committee's work was a recommendation that an authority be created to oversee and run the operation of the center and that a special purpose local option sales tax referendum be held to fund the Center. The fact that it passed by a two-thirds margin showed the community's support for the Center, and their faith in the Committee members who were making these recommendations.

All this is history. But remembering history is an important part of executing present plans, as well as setting a course for the future. An early architect's first design called for the demolition of a historic fire hall, which community members felt could become a centerpiece for the new facility, linking the old with the new. After much controversy, construction of the facility began in 1994 and in 1995 the Authority opened the first phase of the facility, including the Ballroom and Exhibit Hall.

Since that auspicious opening, The Classic Center has become a venue for meetings, special events, and performing arts, providing entertainment, unique dining opportunities, and programs designed for all interests. The Performing Arts Theatre opened in 1996 with the Broadway musical Cats; countless events have graced the stage and attracted thousands of patrons since that first performance, from David Copperfield to Harry Connick, Jr. to Bob Dylan to Blue Collar TV.

A major component of The Classic Center is The Classic Center Cultural Foundation, begun to enhance the cultural offerings of The Classic Center and to support outreach programs that will broaden the exposure of the arts to the citizens of Athens and Northeast Georgia. Created to serve both the artists and patrons of the arts, the Foundation provides funds to purchase art from local artists to be hung in the Center; provides a source of funding for community art exhibits and performances that would like to use The Classic Center but may not be able to afford the space; and assists with the capital improvements that are needed to enhance the experience of patrons and the performers on the stage.

The Classic Center Cultural Foundation draws on the vast local literary talent in the Athens area. A popular program called "Write Around Home" consists of a monthly literary lunch, featuring local authors who read from their works. Among the many talented local writers featured have been Terry Kay, Ed Larson, Maryn McKenna, Michael Thurmond, John Whitehead, Judith Cofer, Augusta Trobaugh, Gene Younts, Julie Cannon,

and Molly Moran. The luncheons are open to the entire community for a modest price, and serve as a way to get to know the author, as well as his work.

Every year The Classic Center Cultural Foundation hosts The Gala, where local artists' works are exhibited and sold. The Foundation purchases work from this event to hang in The Classic Center in honor of the Celebration of the Arts honorees. This art now hangs in honor of Louis Griffith, H. Randolph and Clementi Holder, C.L. Morehead, and John Berry. The works includes Distant Storm by Karekin Goekjian; Langston/Daniel House by Lamar Wood; Spirit of America, Reflections from Athens, 2001 by Alan Campbell; Water by Alison Free; Stages of Light by June McCoy Ball; Cradle of Dreams by Alan Campbell; Over the Cumberland by Greg Benson; Athens/Northeast Georgia Olympic Spectrum by Art Rosenbaum; Jeremy Ayers by Sunny Taylor; Athens Summer 1996 by Students of the Athens Clarke County School District in honor of Jimmy Morris; The Singer by Terry Rowlett; Sound of My Soul by John Ahee; The Lesson by John Ahee; Foundry Street Building Renovation Project/Jere Williams by Jamie Calkin; Greenway by Alan Campbell; Green Pots by Delores Holt; Landscape with Robin's Eggs by Michael Shetterley; Peach Gingerbread by Margaret Anger; View from I.P. by Chris Wyrick; and North Georgia Mountain River by Priscilla Rogers.

At The Gala, the Foundation also awards scholarships to local high school seniors to continue their study of the arts. The Foundation has awarded grants to the Athena Opera Company to mount and present professional caliber outstanding operas and to the Grady College at The University of Georgia to help create the Robert Osborne Classic Film Festival.

Classic Center Cultural Foundation Board of Trustees are Paul Cramer, Archie Crenshaw, Tal Duvall, Linda Ford, Clementi Holder, Tom Hollingsworth, Paul Martin, Don Myers, William Prokasy, and Linda Schramm; the director is Julie Walters. The Classic Center Authority is Jack Crowley, Marilyn Farmer, Linda Ford, Don Myers, and Joseph Napoli; the Executive Director is Paul Cramer.

The Classic Center has never spent any time resting on its laurels. Every season sees new and innovative programs and performances, designed to meet the cultural and artistic needs of all the citizens of Athens and Northeast Georgia. Based on its history, one could say that the future of The Classic Center is bright indeed.

CLASSIC CENTER

Classic Center Cultural Foundation

300 N. Thomas Street
Athens, Georgia 30601
www.ClassicCenter.com

University
Of Georgia

Like two siblings, the University of Georgia and Athens-Clarke County have grown and matured together, sharing, helping, sometimes bickering, but always bonded as inseparable partners in a quest for growth and prosperity.

Established in 1785 when the Georgia legislature approved its charter as America's first public institution of higher education, UGA existed only on paper until 1801 when Josiah Meigs began teaching young boys in a cabin near the Oconee River. That December, the legislature established Clarke County.

In 1806, the cluster of dwellings, hotels, and shops that had sprung up around the school was incorporated as the city of Athens. Also in 1806 the university's first permanent building, Old College, was completed; it remains the oldest building in Athens.

Over the next 200 years university and city grew in tandem, together surviving hardships, sharing resources, and relying on each other for assistance. While an iron fence physically separates town and campus, nothing weakens the spirit of cooperation and mutual reliance that lock UGA and Athens-Clarke County together.

Today UGA is Georgia's largest, most comprehensive educational institution and Athens- Clarke County's dominant economic engine. In 2005, UGA employed more than twenty percent of metro Athens residents and pumped an estimated $1 billion into the county's economy through spending by some 33,400 students and more than 9,500 employees.

The university's motto, "To teach, to serve and to inquire into the nature of things," expresses its obligation as a land grant institution not only to educate young people but also to discover and disseminate knowledge and information that helps society. Instruction, research, and public service in UGA's fifteen schools and colleges span the breadth of human knowledge and endeavor. Students attending UGA in 2005 could choose from among eighteen baccalaureate degrees in 163 fields, thirty-one master's degrees in 141 fields, twenty educational specialist degrees, three doctoral degrees in 101 areas, and professional degrees in law, pharmacy, and veterinary medicine.

Following creation of the HOPE Scholarship, UGA became Georgia's most popular and competitive college, annually drawing some 12,000 applications for a freshman class of about 4,000. Student quality soared as freshman SAT averages climbed some sixty points in ten years and students routinely received the most prestigious national scholarships for undergraduates.

For many students, however, Athens is no longer the only place to study for a UGA degree. In 2005, some 1,600 students participated in study abroad and exchange programs in countries around the world, ranking UGA eighth among the top twenty research universities in number of students studying abroad.

Among UGA's 1,700 faculty are recipients of the Pulitzer Prize and MacArthur Foundation Fellowship, and members of the country's leading scholarly societies, including the National Academy of Sciences, American Academy of Arts and Sciences and National Academy of Engineering.

With research income of more than $160 million and research expenditures topping $313 million in 2005, UGA is one of America's largest research universities and a recognized international leader in such areas as genetics, biotechnololgy, molecular biology, and ecology and environmental sciences. UGA is also rapidly developing strength in the biomedical field. The Biomedical and Health Sciences Institute supports research in biomedicine, bioinformatics, and genomics and genetic technology. The College of Public Health coordinates research, teaching, and outreach programs in health and medicine, and a Center for Drug Discovery promotes research on finding chemical and biological agents to combat infectious diseases and cancer.

Widely known as home of the prestigious Peabody Broadcasting Awards, UGA also boasts excellence in visual and performing arts through its respected schools of music and art and the Georgia Museum of Art. The university is also home to the State Botanical Garden, the Georgia Museum of Natural History, and the Georgia Writers Hall of Fame.

Superior academics, outstanding faculty, affordable costs, and rising reputation have vaulted UGA into the realm of America's best public universities. In 2004, U.S. News and World Report ranked UGA nineteenth among America's top fifty public institutions--the fifth straight year UGA made the Top Twenty. Kiplinger Magazine ranked UGA fourth among the twenty best public colleges that "combine great academics with reasonable cost." Many departments in the colleges of business, education, journalism, and public and international affairs were listed among the best in the country.

In their third century of partnership, UGA and Athens-Clarke County have never been more resolved to achieve common goals of building a stronger community and state.

The University of Georgia

www.uga.edu

The Artists

Carol Downs

home phone: (706) 543-5665

e-mail: carold@negia.net

mailing address: P.O. Box 896,

Watkinsville GA 30677

Pages 11, 16, 72

Christine A. Langone

home phone: (706) 546-5592

e-mail: langonec@mindsping.com

Pages 63, 89

Jo Adang

cell phone: (706) 540-3819

home phone: (706) 548-8330

e-mail: j_adang@hotmail.com

Page 88

Chris Cook

e-mail: chris@chriscookartist.com

website: www.chriscookartist.com

Page 52

John Gholson

website: johngholson.com

Pages 37, 71, 78

Jill Leite

cell phone: 207-0927

home phone: 549-4442

e-mail: jleite@charter.net

fax: (706) 549-9474

Page 20

Celia Brooks

home phone: (706) 769-4838

e-mail: tpopps2k@yahoo.com

fax: (706) 613-3833

other: (706) 613-3623 x 224

website: athensart.org

Pages 27, 87

William Vickers Chittick (deceased)

Bill Chittick, 585 White Circel, Apt.6

Athens, GA 30605

706-543-4895

In Memory of William Vickers Chittick

Pages 70, 91

Jean Gibson

home phone: (706) 546-1305

e-mail: jgibson91@yahoo.com

home address: 295 Greencrest Dr.,

Athens GA 30605

Pages 66, 73

Angela Moore

e-mail: amoore@uga.edu

Pages 19, 51, 59, 70

Van Burns

home phone: (706) 549-9695

e-mail: misobar@mindspring.com

Page 57

Paul Davidson

home phone: (706) 548-6404

e-mail: edisto01@bellsouth.net

home address: 195 Devonshire Dr.,

Athens GA 30606

Pages 15, 32, 52, 73, 74

Bruce Knecht

home phone: (706) 769-5764

e-mail: bwknecht@yahoo.com

Page 44

Stan Mullins

650 Pulaski Street

Athens, GA 30601

706.227.2335

www.stanmullins.com

stanarts@aol.com

Pages 51, 55, 74, 81, 90

Jamie Calkin

home phone: (706) 546-4703

e-mail: kjcalkin@hotmail.com

website: www.jamiecalkin.com

Pages 8, 35, 56, 68

Jack Davis

212 Hampton Point Drive

St. Simons Island, GA 31522

Page 63

Bryan (Knute) Knudson

home phone: (706) 369-1563

e-mail: artknute@yahoo.com

Page 84

Gwen Nagel

home phone: (706) 546-9655

e-mail: gnagel@mdindspring.com

home address: 168 Red Fox Run,

Athens GA 30605

Pages 23, 64, 88, 89, 91

Mary Padgelek
home phone: (706) 353-6527
e-mail: marypadgelek@charter.net
website: www.padgelek.com
Pages 28, 58, 60, 65, 69, 76, 79, 82, 84

W. Joseph Stell
cell phone: (706) 202-0780
home phone: (706) 549-3950
e-mail: wjstell2@charter.net
home address: 320 Rivermont Rd., Athens GA 30606
Page 77

John Ahee
305 Brookwood Dr.
Athens, GA 30605
e-mail: jahee21@yahoo.com
Pages 36, back cover

Richard Olsen
225 West Clayton Street
Athens, Ga 30601
706-338-0548
www.mercuryartworks.com
Page 43

Alice Pruitt
cell phone: (706) 540-3906
home phone: (706) 543-7633
e-mail: pruitt2696@aol.com
fax: (706) 543-5098
Pages 13, 62

Kathryne Whitehead
75 Point Blue
Sautee-Nacoochee, Georgia 30571
Page 75

Brent Chitwood
382 Argo Rd.
Royston, GA 30662
e-mail: rembretn@negia.net
Pages 50, 72

Charlene Olson
739 Cobb St.
Athens, GA 30606
e-mail: norm.olson@charter.net
Pages 30, 61

Dennis Harper
225 West Clayton Street
Athens, Ga 30601
706-338-0548
www.mercuryartworks.com
Page 42

Jeff Owens
225 West Clayton Street
Athens, Ga 30601
706-338-0548
www.mercuryartworks.com
Page 46

Nancy Roberson
home phone: (706) 543-1680
Pages 24, 66, 75, 77

Lamar Wood
website: lamarwood.com
email: lwnow@earthlink.net
tel: (706) 742-2757
Cover art

Jim Herbert
225 West Clayton Street
Athens, Ga 30601
706-338-0548
www.mercuryartworks.com
Pages 39, 48, 49

Art Rosenbaum
225 West Clayton Street
Athens, Ga 30601
706-338-0548
www.mercuryartworks.com
Page 40

Michael Shetterley
cell phone: (706) 207-8039
e-mail: mikeshet@yahoo.com
website: www.michaelshetterley.com
Page 86

Chris Wyrick
cell phone: (706) 338-0548
e-mail: christopherwyrick@yahoo.com
Pages 49, 53, 80, 85, 92

Hannah Jones
225 West Clayton Street
Athens, Ga 30601
706-338-0548
www.mercuryartworks.com
Pages 44, 45

Terry Rowlett
225 West Clayton Street
Athens, Ga 30601
706-338-0548
www.mercuryartworks.com
Page 47

René D. Shoemaker
work phone: (706) 542-8292
home phone: (706) 543-9093
e-mail: rds@coffeecuppress.com
Page 83

Artists photography by:
Janis Dalton
Southern Images
(706) 795-3335

Keith Karnok
1101 Hillcrest Dr.
Watkinsville, GA 30677
e-mail: keithkarnok@yahoo.com
Pages 54, 71, 76

Keith E. Sanders
phone: (706) 549-7086
e-mail: sandathens@bellsouth.net
website: www.keithsandersart.com
Pages 67, 83

Index